The Postcard History Series

Musing through Towns in
Mississippi

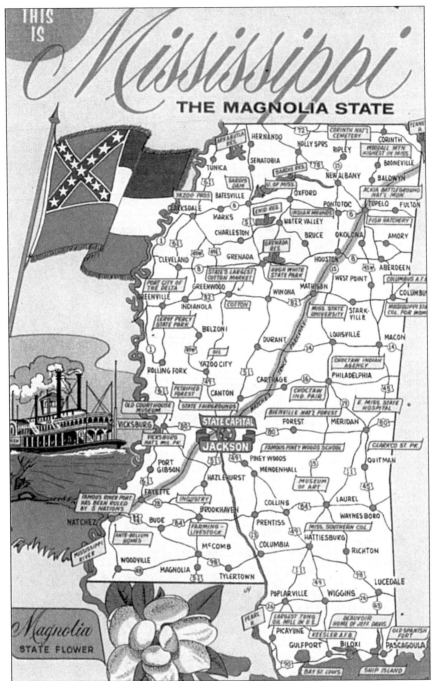

This map was published on a postcard around 1950. It shows the old state highways of 51 North and South, 80 East and West, and 90 East and West, along with others that were established before interstate highways crossed the State of Mississippi. These old state highways have served Mississippians in some form since 1924. For land areas encompassed in each chapter, a portion of this map was reproduced and placed at the beginning of that chapter.

THE POSTCARD HISTORY SERIES

MUSING THROUGH TOWNS IN
Mississippi

Wynelle Scott Deese

ARCADIA

Copyright © 1999 by Wynelle Deese.
ISBN 0-7385-0038-0

Published by Arcadia Publishing,
an imprint of Tempus Publishing, Inc.
2 Cumberland Street
Charleston, SC 29401

Printed in Great Britain.

Library of Congress Catalog Card Number applied for.

For all general information contact Arcadia Publishing at:
Telephone 843-853-2070
Fax 843-853-0044
E-Mail arcadia@charleston.net

For customer service and orders:
Toll-Free 1-888-313-BOOK

Visit us on the internet at http://www.arcadiaimages.com

Bibliography

Biographical and Historical Memoirs of Mississippi. Chicago: The Goodspeed Publishing Company, 1891.

Cox, James. *Mississippi Almanac 1997-1998: The Ultimate Reference on the State.* Tallahassee: Lithography by Rose Printing Co., Inc. , 1977

McIntire, Carl. *Jackson: The Way We Were, Old Postcard Views from the Collections of Forrest L. Cooper and Donald F. Garrett.* American Yearbook, undated.

McLemore, Richard. *A History of Mississippi, Volumes I & II.* Jackson: University & College Press of Mississippi, 1973.

Rowland, Dunbar. *History of Mississippi, The Heart of the South.*Chicago-Jackson: The S.J. Clarke Publishing Co., 1925.

Scott, Sylvia Steele. *Northwest Iowa to South Dakota to South Mississippi.*1955.

Sullivan, Charles and Murella Powell. *The Mississippi Gulf Coast: Portrait of a People, An Illustrated History.* United States: Windsor Publications, 1985.

Contents

Bibliography		6
Introduction		6
1.	On and Northeast of Highway 51	9
2.	Northwest of Highway 51	29
3.	Jackson, the Capital of Mississippi	49
4.	Highway 80 West and West of Pearl River	67
5.	Highway 80 East and East of Pearl River	87
6.	The Coastal Towns on Highway 90	111

Introduction

"Musing" was a carefully chosen word for this book, meaning to reflect or ponder about a subject, and in this case, the subject is the whole state of Mississippi. This is not a fanciful or daydreaming type of musing, but rather a contemplation or thoughtful observation of the past. This reflective process helps to mirror one's own personal involvement with Mississippi as we observe pictures of the early 1900s. The title sets a tone of personal reflection about early 20th-century Mississippi.

Mississippi suffered drastically during and after the Civil War. By 1900, the majority of the population (94.6%) were still farmers with little industry and no organized network of roads. Mississippi had at least four major connecting roads across the state; the most famous was the Natchez Trace that opened at the beginning of the 19th century. Destructive rivers periodically flooded the Delta, and the state had less electrical power resources as compared to others at that time. State government had always focused on Civil War recovery rather than developing industry.

At that time, Vicksburg was the largest city while Natchez was the third largest, and Greenville was fifth in size. They were all located along the Mississippi River. Meridian was the second largest city because of an established north-south railroad, and Jackson was fourth as more railroads were reaching the city. While water transportation was important to the early development of cities, railroads and roads became the source of development in the 1900s. Meridian grew to be the largest city through 1920, while Jackson became the largest in 1930 and has continued to be the largest city in the state. Although Vicksburg was the third largest city from 1910 until 1950, Biloxi became the third largest after 1950. By the 1950s, the State of Mississippi had decreased its dependency upon farming, developed adequate roads throughout the state, and provided electrical power to even the most remote areas, resulting in expanded industry, increasing business, and economic growth.

Many Mississippians lived their whole lives within the state, while others, such as my husband and I, after he earned a law degree and I earned a graduate degree from the University of Mississippi, moved to another state for professional opportunities not available in Mississippi during the early 1960s. It was our early home and is still home to many of our relatives.

Mississippi holds much of our family history. Both sets of my grandparents moved to George County, Lucedale, Mississippi, between 1913 and 1923. They built or bought homes that have survived. They cultivated family farms and history that has survived. Sylvia Scott, my father's mother, wrote about the family in those days.

My father, having completed his civil engineering degree at the University of Mississippi during the Depression, assumed the overdue taxes on my mother's family farm, the Burge home, while waiting for an engineering job. During this difficult time, many Mississippians lost their family farms due to unpaid taxes. Grandfather Burge had died, and his surviving wife could not manage the farm. My parents managed the farm until other family members took over. That farm continues in the L.D. Burge family today in Lucedale, Mississippi.

My father's first engineering job was a position with the Tennessee Valley Authority (TVA)

to build dams for flood control and to provide electric power for surrounding cities. Our family moved to each town as dams were built. Since roads at this time were barely passable, families moved with the jobs. During his first four years of working with TVA, my father moved the family 17 times, making it difficult for my brother to attend grade school. I was born in Euporia, was moved 6 weeks later to Tupelo, and never again lived in Euporia.

After World War II (WWII), my parents settled in Clinton, Mississippi, where my father became an engineer with the Mississippi Highway Department, one of several who supervised the building of Mississippi highways. My father retired many years later, having seen a network of Mississippi state highways created and the Interstate Highway System proposed, one of which ran through Clinton, Mississippi. The old State Highway 51 North and South would later parallel Interstate 55, State Highway 80 would became part of Interstate 20, and old State Highway 90 would parallel Interstate 10. All of these developments were just plans when my father retired, but they are now a reality in Mississippi.

My first job was in Jackson, Mississippi, at the University of Mississippi Medical Center in 1963, as a psychologist in the Department of Psychiatry. A Psychiatry Department had just been added to the new medical center, and I was hired to conduct psychological tests on individuals admitted to the unit. The medical center was located on the grounds of the old Mississippi Lunatic Asylum, and an old brick sidewalk from the asylum was still there. My interest in psychiatric history was sparked by the old asylum's brick sidewalk but did not culminate until after working in two other mental health facilities in Kentucky, one of which was the second oldest lunatic asylum in America, later known as Eastern State Hospital of Lexington, Kentucky.

I married a man who grew up in Batesville and Greenville, Mississippi. His father, W.H. Deese, was district supervisor with the U.S. Corp of Engineers and was employed for 45 years. He directed flood fights on the Mississippi River in earlier days and supervised Northwest Mississippi dams for flood control in the Mississippi Delta. His mother, Francis Wheeler Deese, grew up in Greenville and witnessed, as a child, the destruction of the 1927 flood. His grandfather, B.C. Wheeler, was a banker in Greenville and the Washington County treasurer. His great grandfather, Dr. W.C. Wheeler, was born in Tishomingo County, Mississippi, to parents from Kentucky. He graduated from the Nashville Medical College, served the Confederate Army as physician, and practiced medicine the rest of his life in Alabama. My husband and I, along with many members of our family, have lived throughout the State of Mississippi for many years. We, along with our families, participated in the growth and development of Mississippi from the earliest part of the 20th century. It is in their memory that I write this book.

Brodie Crump, when writing his usual article for the *Delta Democrate* around 1965 in Greenville, wrote about my husband and I moving to Kentucky. He stated, "History tells us that Greenville and Washington County were settled largely by Kentucky people. Nowadays, just look at the folks from the Greenville area resettling in Kentucky, now Jim Deese and his wife, the former Wynelle Scott of Clinton, Mississippi," as he reminisced about the Deese family. Brodie Crump failed to mention one Kentuckian who moved to Greenville, later discovered by this author when collecting history about the Kentucky Lunatic Asylum, Dr. Sam Theobald. A physician at the Kentucky Asylum in 1840, he later moved to Greenville, Mississippi, and married Mrs. W.W. Blanton, a widow. She provided the land for rebuilding Greenville after the Civil War and named Theobald street for her second husband. Another Mississippian, Dr. Thomas D. Clark, born in Louisville, Mississippi, wrote Chapter 33 of *A History of Mississippi* in 1973 (see page 4), moved to Kentucky, and has become known as a Kentucky historian. Since my husband and I spent 31 years in Kentucky, this migration from Mississippi to Kentucky, and vice versa, is of interest to me and will be explored throughout this book.

The postcards for this book came from about 25 years of collecting Mississippi views. Each view of a town will start with the earliest picture and proceed forward, if available, until the 1950s. A few family pictures were added when deemed appropriate, and historical data about

specific individuals will be included. Old postcards are a tremendous source of history, and this book can demonstrate that value with Mississippi history.

The book was divided into six chapters, representing different sections of the state. While such divisions may not be commonly used in the state of Mississippi, these divisions were necessary for equalizing pictorial coverage of the entire State.

MAIN PRODUCTS OF MISSISSIPPI C. 1990.

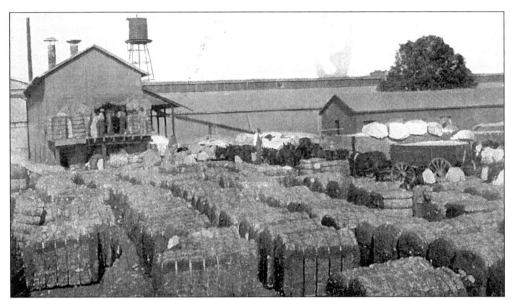

COTTON. Pictured here is a cotton gin in Greenville, Mississippi.

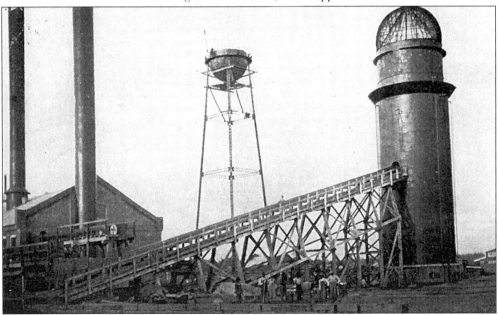

LUMBERING INDUSTRY. Pictured here is a conveyor and burner of the Lamb-Fish Lumber Company in Charleston, Mississippi.

One
ON AND NORTHEAST OF HIGHWAY 51

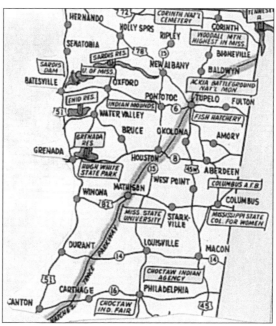

This northeast side of Mississippi has a different Civil War history than the rest of the State. The greater part of this hilly country consisted of individuals who were either small slaveholders or non-slaveholders, not under the domination of "King Cotton." This was considered the "disloyal country," although several battles between the North and South were fought here. While Tishomingo County pointed the way, and surrounding counties followed, defection to this area occurred frequently during and after the Civil War. A type of backwoods people continued to live here with minimal subsistence and isolation until roads were built in the 1920s, and industry came to the area in the 1930s.

Natural gas, which was the first major source of industrial power in Mississippi and was initially of little importance to the state's industrialization because of the localized nature of the systems, was developed near Amory and led to a pipeline carrying natural gas to Tupelo and Aberdeen by 1927. Public power was first introduced to this area in 1936, when the TVA became a supplier to the area. As rural electrification became available, more industry located in this area, and the economy improved for the local population.

Now, we will muse through the towns, starting at the northeast top part of Mississippi at Corinth. This postcard shows Waldron Street and the Roger's Monument of Civil War fame.

This view shows the courthouse and the Roger's Monument from a different angle. Corinth had approximately ten battles from April 1862 to January 19, 1865, exposing the city to successive occupations by Federal and Confederate forces.

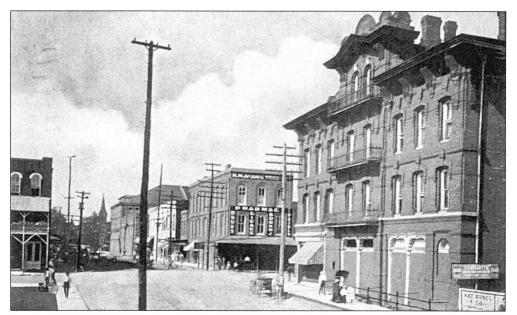

This view of Corinth, Mississippi, shows Cruse and Filmore Streets around 1906. Corinth was the seat of justice for the county and was situated 93 miles from Memphis, Tennessee. Two railroad lines, the Memphis & Charleston and the Mobile & Ohio, provided the town with opportunities for growth in the 20th century.

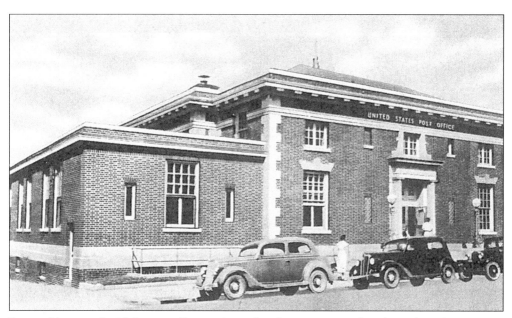

Pictured here is the U.S. post office in Corinth. This view was taken later than the previous views, showing cars around the 1930s and 1940s.

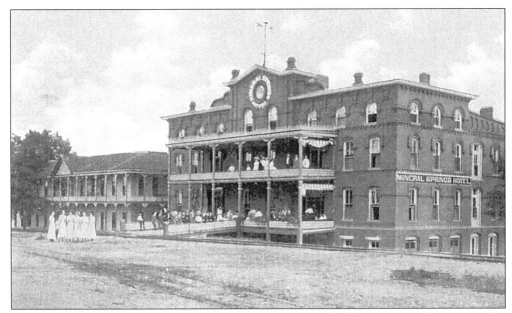

Continuing southeast, there is a town too small to be included on our 1950 map. In the furthermost part of Tishomingo County lies the town of Iuka, Mississippi. Iuka had six battles, occurring mostly in the early part of the Civil War. This is a view of the Mineral Springs Hotel with a postmark of 1912.

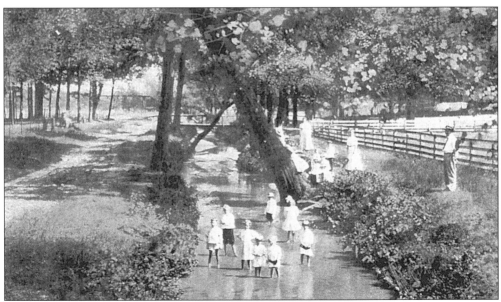

Children are shown playing in the Mineral Springs Park at Iuka. These springs were believed to possess various medicinal and healing properties. The springs were as the Native Americans had left them, untouched by human intervention and refreshing.

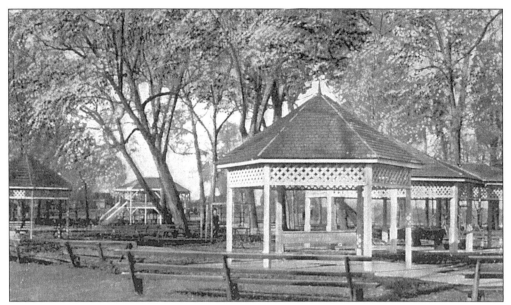

The Mineral Springs drew the attention of Prof. H.A. Dean in 1882, and he opened the first successful independent normal school in the South, known as the Iuka Male Academy and Female Academy.

This postcard, made between 1915 and 1930, shows the business section of Iuka, built around a town square. Mr. George P. Hammerly was a general merchant in Iuka and a trustee of the Iuka Female Institute for 25 years, until the early 1900s.

Moving south to Lee County, we find Tupelo, Mississippi. This postcard shows an early 1920s view of the Strand Theater. Tupelo was located at the junction of the Kansas City, Memphis & Birmingham and Mobile & Ohio Railroads, making it a potential leader in cotton and manufacturing in northeast Mississippi.

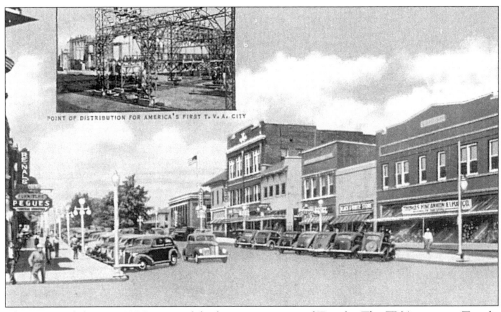

This postcard shows a 1930s view of the business section of Tupelo. The TVA came to Tupelo between 1933 and 1934, making it the first such city in the country.

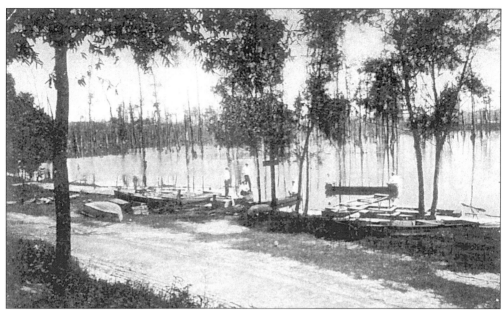

The first concrete highway south of the Mason-Dixon line, Lee County Road #681, was completed in 1915 at Tupelo. Tupelo was also the largest northeastern Mississippi town that the Natchez Trace Parkway went through into Alabama and Nashville, Tennessee. The Natchez Trace, running from Natchez to Jackson to Nashville, was a frontier road until the 20th century, when it was officially added to the National Park System in 1938 and the road was paved. The Natchez Trace can be seen on the 1950 map on page 2. These two postcards feature park lake scenes of Tupelo. The area is typical of the natural setting found around the Natchez Trace Parkway.

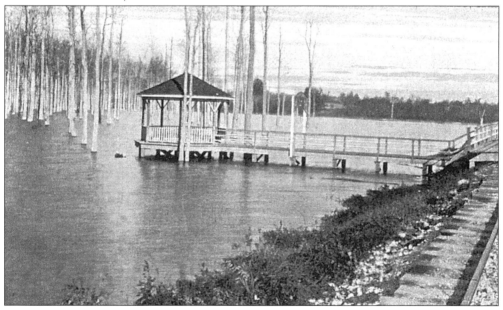

Continuing west from Tupelo into Pontotac County, we reach a small town, Toccopola, that is not on the 1950 map. This photo postcard shows the home of Prof. W.B. Gilmer, who founded the Toccopola High School in 1884. Such information, while available on this old postcard, has not been confirmed or discredited by other sources. The photo postcard appears to have been taken from a picture in a book around 1910.

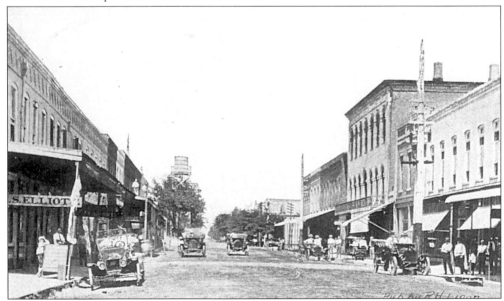

Going south, this postcard shows a view of Main Street in Okolona, Mississippi. Notice the dirt street, water tank, and utility poles.

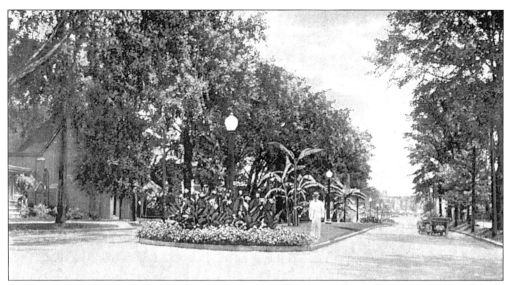

Continuing south, we find Aberdeen, Mississippi. This view shows West Commerce Street. Aberdeen was home to Dr. W.A. Sykes, whose family became one of the prominent families in the state, filling many positions of honor and trust. Eugene Sykes, son of Dr. Sykes, was a member of the state Supreme Court with distinguished ability. He married Malvina Scott in 1903. Her father, Hon. Charles Scott, was a prominent figure in the legal history of the state and one of the wealthiest cotton planters.

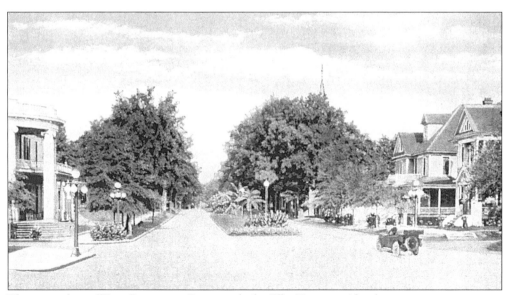

This view shows West Commerce Street with the Elks Home in Aberdeen.

Continuing south in this northeast section of Mississippi is a real photo postcard showing cotton in the gin yard at West Point, Mississippi. The postcard was produced by M. Tees in 1907.

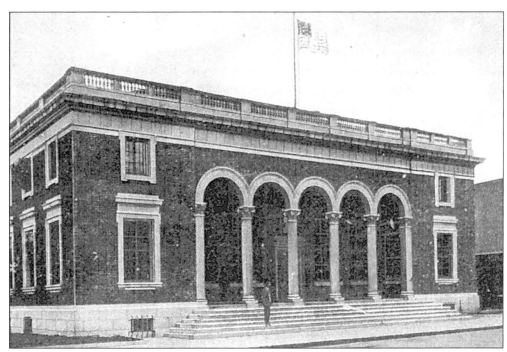

This real photo postcard shows the post office that operated in West Point from 1915 to 1930. The postcard was sent in October of 1918.

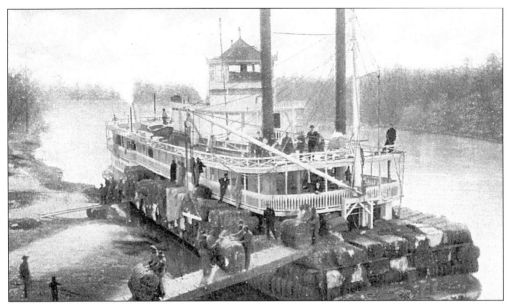

From West Point, we travel southeast to Columbus. The next six postcards will show views of that town. This postcard is of the *Steamer American* on the Tombigbee River unloading cotton.

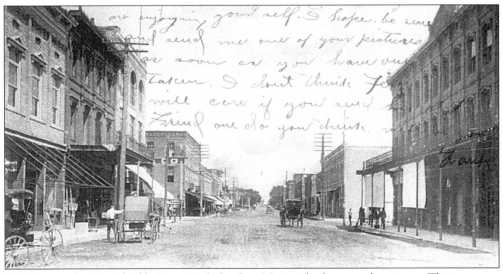

This is an early view of Fifth Street in Columbus. Notice the horse and carriages. The town was incorporated in 1822, and the Tombigbee Cottonmills Company opened in 1887 and became a major employer. This handwritten message was "Frank" asking for a picture from "Miss Adele Brown." It was mailed in June of 1908 from Columbus to Somerset, Kentucky.

This is a view, c. 1915–1930, of Main Street looking West in Columbus. Notice the early automobiles. Many of the early settlers of Columbus claimed to be from better families of Virginia, South Carolina, Georgia, and Kentucky, such as Dr. J.D. Hutchinson.

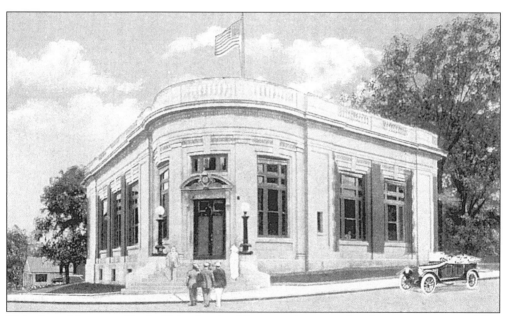

This view of the post office in Columbus is of the same time period as the previous postcard. Dr. J.D. Hutchinson settled in Columbus in1885, gave up medicine, and became engaged in the cotton business. His father, Dr. J.P. Hutchinson had been a physician in Lexington, Kentucky. Dr. J.D. Hutchinson was very successful and had five children who were part of Columbus for many years.

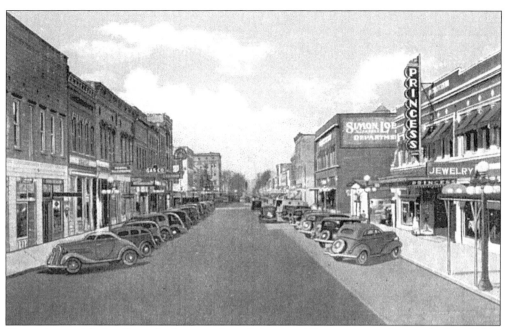
Shown here is Market Street looking north in Columbus. This view was taken in the late 1930s.

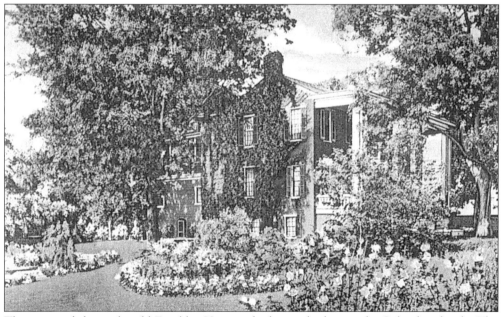
This postcard shows the old Franklin Home, which was the home of a Columbus family. The card was published between 1930 and 1945 and shows the beautiful foliage around the home.

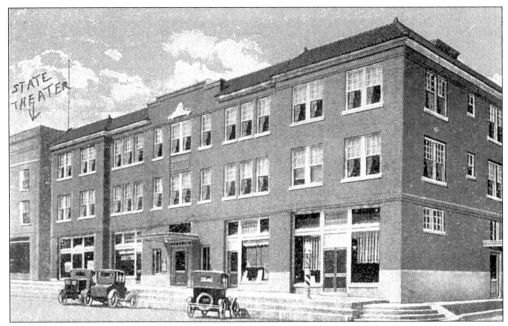

If we continue southwest of Columbus, we will find Starkville, Mississippi. This postcard shows the Chester Hotel and State Theater in that town. Notice the early cars and the barber shop pole.

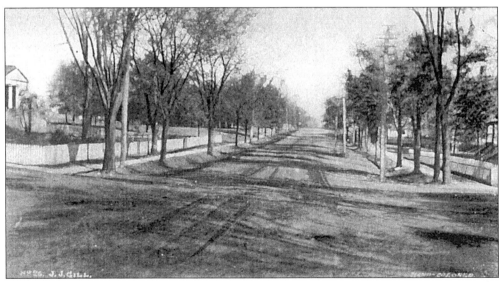

This view of Starkville shows West Main Street, a dirt street, in the residential section. The postcard was published between 1907 and 1915 by J.J. Gill in a series. This one numbered 26. Hopefully, more cards in that series have survived.

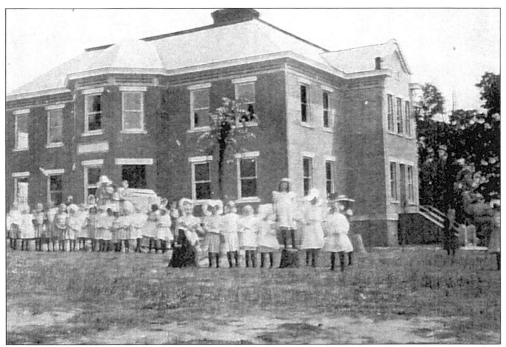

This photo was taken of the Starkville Graded School around 1915. Our journey has taken us to the southern part of this section in *Postcards of Mississippi*.

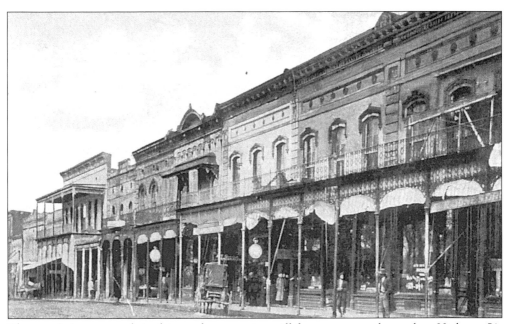

The remaining postcards in this northeast section will focus on towns located on Highway 51, starting from Canton, Mississippi, towards the northern border. This postcard of Canton, looking north on Liberty Street, was made between 1901 and 1907.

The postcards on this page show two homes of Mr. and Mrs. W.O. Glines in Durant, Mississippi. Handwritten on this postcard was, "This a picture of our home on the 21st of March, 1908," to Mrs. Anna Lawrence in Cambridge City, Indiana.

On this postcard was the handwritten message, "Our new home," mailed in 1909 to Mrs. Anna Lawrence from Mr. and Mrs. W.O. Glines. How proud they were of their new home. It is remarkable that both postcards survived together.

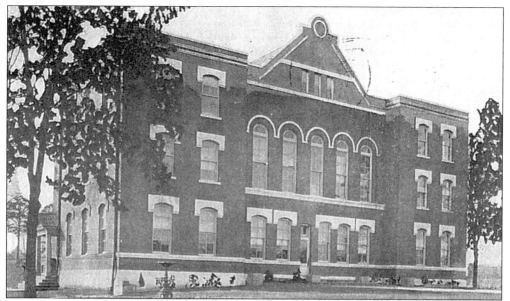

Continuing north on Highway 51, this postcard shows the grammar school in Winona, Mississippi, sometime between 1915 and 1930.

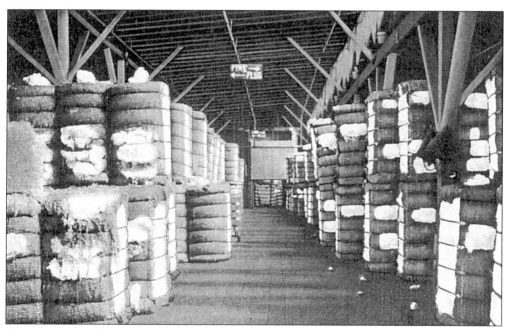

Continuing north, this postcard shows the inside of a cotton warehouse in Grenada, Mississippi, around the early 1950s. This postcard is interesting because of the apparent wood building where cotton, being very flammable, was stored. A sprinkler system of pipes can be seen in the roof. Signs (two of which can be seen) point to fire plugs throughout the building, showing the concern for fire in the building.

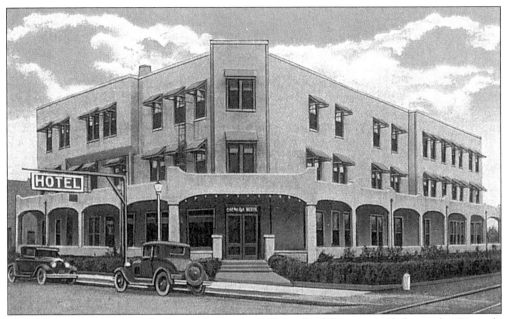

The following two postcards depict the town of Grenada. This postcard shows the Grenada Hotel around the 1920s. Notice the railroad tracks on the right. Grenada was located on the main line of the Illinois Central Railway. It was one of the largest receivers of cotton on the railway at that time.

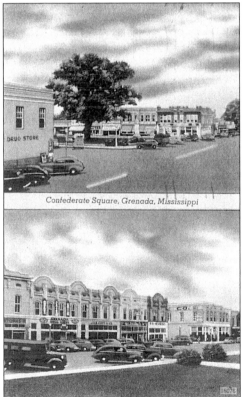

Confederate Square, Grenada, Mississippi

The business portion of Grenada was built about half a mile from the railroad, with every branch of business being represented in a square of 40 to 50 stores. That business district, Confederate Square, was still present around the 1950s, and is shown in this postcard.

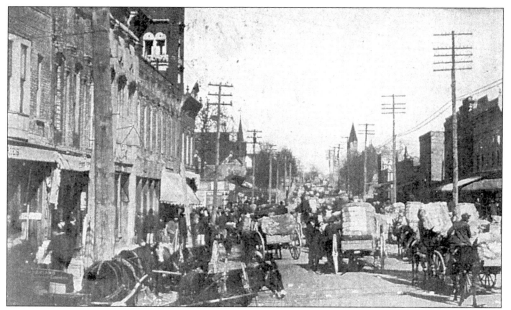

The following two postcards depict the town of Water Valley, which is actually east of and not on Highway 51. This view, published between 1901 and 1907, shows an early street scene with 3,200 bales of cotton being sold on the streets of Water Valley.

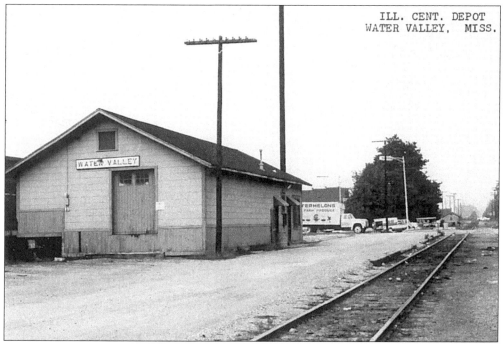

Shown here is a later view of the Water Valley Illinois Central Depot. While the cars are more current, the depot has been there for many years.

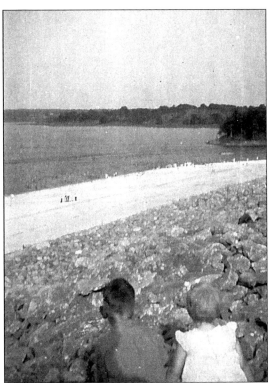

Both of the images on this page depict Sardis Dam. This family picture shows the author on the right and her brother, looking at Sardis Dam in 1941. Unknown to the author, her future father-in-law was superintendent of that dam.

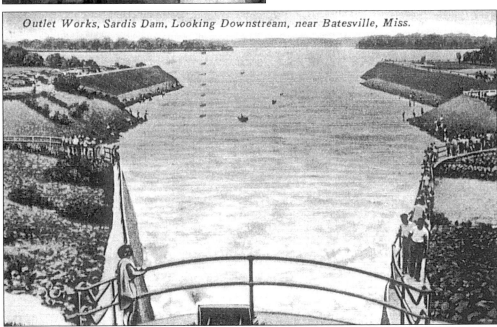

This postcard, with a postmark of 1949, shows the outlet works of Sardis Dam. This was one of the four dams created to reduce flooding in the Mississippi Delta. There were many other important towns in this section that were not included in this chapter, mainly because, after searching for years, early postcards of these towns were not available to the author. Hopefully, there are still more early Mississippi postcards that have not yet been discovered.

Two
Northwest of Highway 51

This northwest section of Mississippi includes rich Delta land along the Mississippi River and the largest cotton market. That land has historically flooded and attempts to reduce the flooding were made by building levees. The Civil War succeeded at destroying the levees, either by war or neglect, leaving the whole Delta as a wilderness. A Levee Board was created after the floods in 1883, for the purpose of building a uniform levee that could hold high water That levee did not hold in 1927 as the Delta suffered a disastrous flood. It was one of the greatest disasters this country had suffered up to that time, paralyzing the economic and social life for thousands of people and land. The United States Army Corps of Engineers initiated in 1936 four flood control lakes on tributaries of the Yazoo River, improving the economic survival of the area into the middle of the 1900s. One of these dams, Sardis, is shown on postcards in Chapter I, since it was east of Highway 51. All four dams helped to drain flood waters from the northcentral hills of Mississippi, protecting lives and property and significantly protecting the lives of those who lived there. During the early 1900s, electric power was available in isolated towns. A consolidation of electrical power was first achieved in this area in 1923 when the electric power systems of Greenville, Jackson, and Vicksburg were organized into the Mississippi Power and Light Company, providing additional growth.

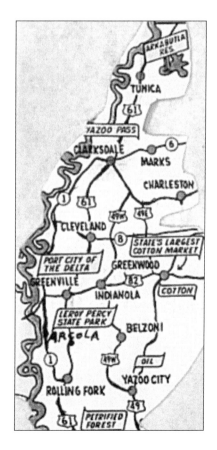

We start with the northern most town available on postcards, Clarksdale, Mississippi. This general view of Clarksdale, Mississippi, was made between 1901 and 1907. Clarksdale was founded in 1869 by John Clark, who started in the timber business and accumulated land where Clarksdale stands. He opened a store and sold lots. It was not until the Louisville, New Orleans & Texas Railroad arrived that the town grew. Mr. Clark continued to prosper, and he married a native of Kentucky, Eliza Alcorn. Their son, James Alcorn Clark, later became a senator and governor of Mississippi.

This early postcard, published between 1907 and 1915, shows the Alcazar Building on Delta Avenue in Clarksdale on a dirt road. Notice the barber shop pole and stop light.

This postcard view, published around the same time period as the previous view, shows the new Alcazar Hotel without any surrounding buildings. Therefore, the location is difficult to identify.

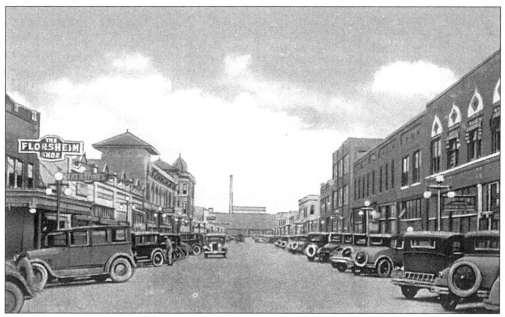

This postcard view, published between 1915 and 1930, shows a later time on Delta Avenue, looking south with a building similar to the previous Alcazar building on the left. The road is paved, and Clarksdale has grown in population and business.

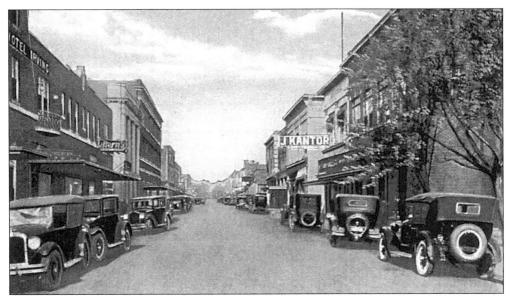

Continuing south from Clarksdale, we come to the town of Greenwood, Mississippi. This postcard is a downtown view of Howard Street in Greenwood around the 1930s. The Hotel Irving is on the left, and the J. Kantor Building on the right.

This postcard from the 1940s shows the same view one block away, with the Hotel Irving and the J. Kantor Buildings on the left and right sides.

This view from the 1940s shows the post office in Greenwood.

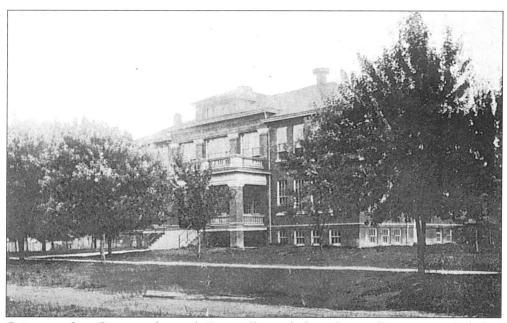
Going west from Greenwood towards Greenville, we find another small town not included on the 1950 map, Itta Bena, Mississippi. This postcard shows the high school building at Itta Bena published between 1901 and 1907 by E.T. Heard.

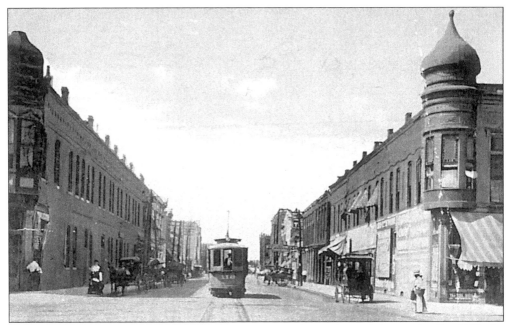

Continuing westward we reach Greenville, Mississippi. It was burned during the Civil War by the Federal naval authorities. When the present Greenville was founded after the war, Blantonia Plantation was selected as the most eligible site in Washington County. Mrs. Theobald, widow of W.W. Blanton and owner of Blantonia, provided land for the city and the Methodist Church. This view, from between 1907 and 1915, shows south Poplar Street.

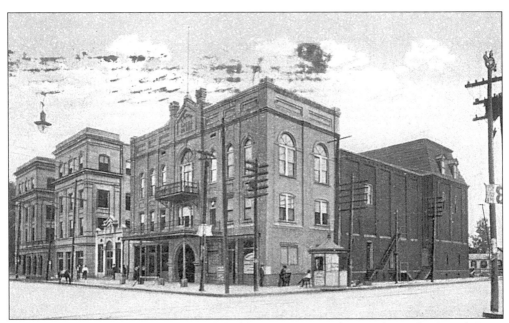

This view of the same time period, published between 1901 and 1907, shows the Grand Opera House that such people as the Theobalds, Starlings, Johnsons, and Wheelers attended. in the early 1900s.

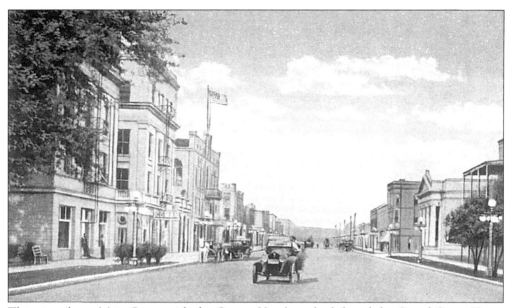

This view shows Main Street with the Cowan Hotel on the left and the Grand Opera House next to the First National Bank across the street on the right.

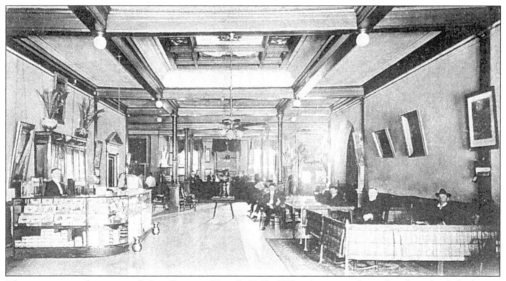

This is an inside view of the Cowan Hotel. B.C. Wheeler stayed in this hotel while being considered for the First National Bank job that he later obtained.

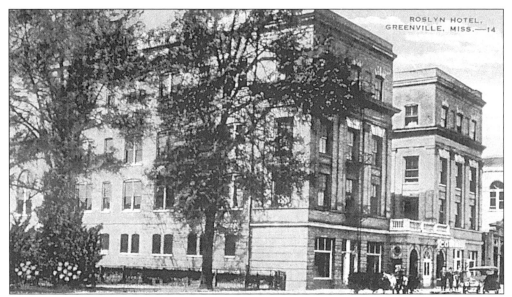

This hotel is identified on this postcard as the Roslyn Hotel, but a sign in front reads "Cowan." The postcard was postmarked 1930, later than previous pictures of the Cowan, implying that it may have changed names at one time.

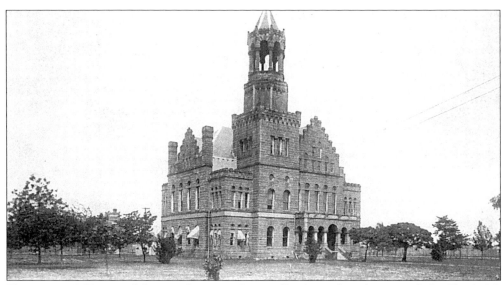

This is a c. 1907 view of the courthouse in Greenville. An earlier chancery clerk, Claude M. Johnson of Greenville, had parents who settled in Greenville around 1830 from Lexington, Kentucky. He married Miss Alice Hunt, whose parents William and Prue V. Hunt also had settled in Greenville from Kentucky. C.M. Johnson was elected chancery clerk of Washington County in 1878 and served until 1887. That family continued to be a part of Greenville for generations.

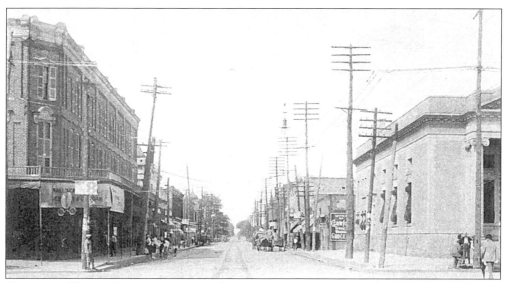

This view of Poplar Street shows more of the electric power lines on that street. Note that on the right is the same building that is seen in the next postcard.

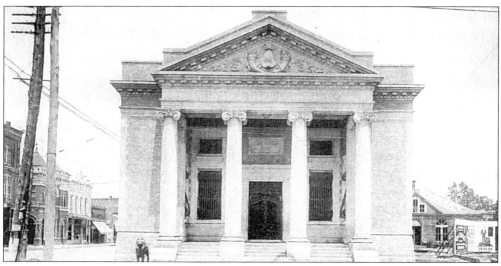

Shown here is the First National Bank of Greenville in 1906. Francis Wheeler Deese, whose father, B.C. Wheeler, was employed here, remembers playing on the lion in front of the bank as a child. Lyne Starling, brother to Maj. William Starling, started as a clerk in this bank and later became an owner of considerable property.

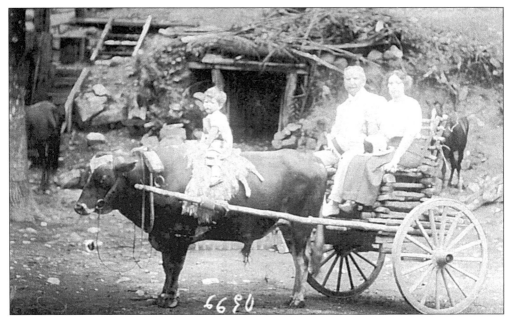

This is a family postcard of B.C. and Caroline Wheeler and their first child. They were the parents of Francis Wheeler Deese, who was not born at the time of this picture. Caroline Golden Wheeler, pictured before her marriage on page 79 while attending the Port Gibson Female College, is married in this picture and on vacation with her husband and their first child.

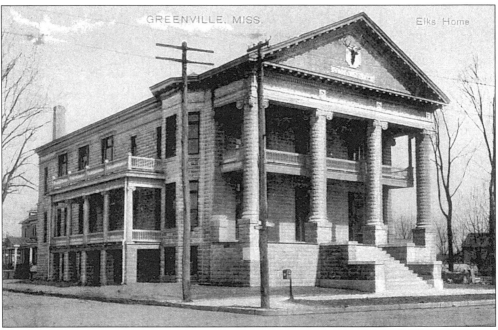

The Elks Home had a ballroom upstairs where many dances were held. Mr. C.W. Dudley was a member of the Greenville Elks Club and tax collector for the Levee District. His father, Dr. C. Watkins Dudley, and his grandfather, Dr. B.W. Dudley, were well-known physicians in Lexington, Kentucky.

This view shows Washington Avenue in Greenville with the Elks Home and the Methodist church on the left. The Greenville Sanitarium, identified as being between the Elks Home and the Methodist church, was established in 1903 with eight beds. It was not there in the middle of the 1900s.

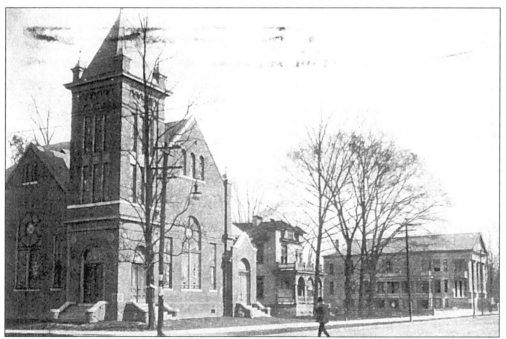

This is a similar but closer view of the Methodist church, sanitarium, and Elks Home. Mrs. Theobald, who lost her second husband in 1867, Dr. Sam Theobald from Kentucky, and whose plantation became the present Greenville, was a member of this Methodist church until her death in 1888.

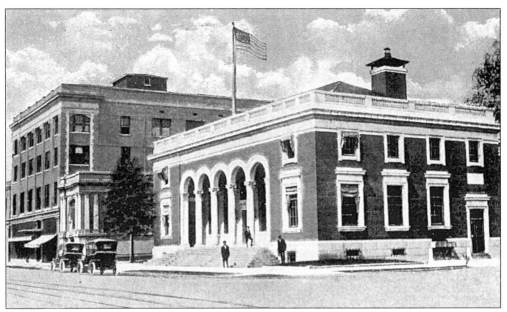
Shown here is the U.S. Post Office and Customs House around the 1930s.

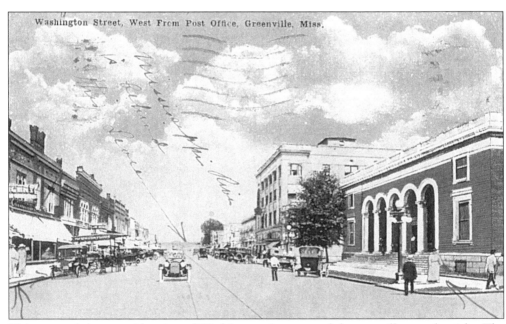
This postcard shows a wider view of Washington Avenue and the post office on the right. The sender marked on this postcard, "Principle Business Street and Mississippi River is behind this levee." The sender also marked two people on the left as "Here we are on our way to post office to mail this card to you," drawing an arrow to the post office. The postcard was postmarked 1921.

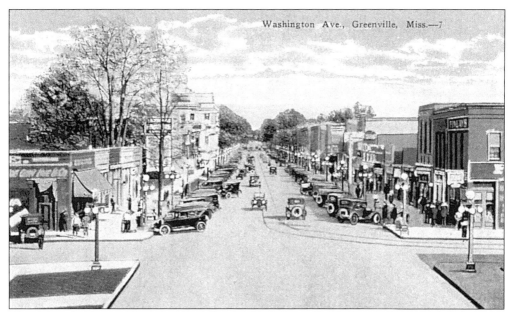

This view shows another part of Washington Avenue. The postcard was published between 1915 and 1930. The sender of this postcard wrote the following message, "The coloring is hopeless! The cards are so cheap but they're the only one I can get," obviously talking about the postcard view.

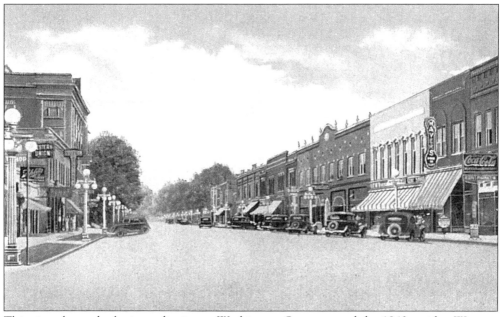

This view shows the business district on Washington Street around the 1940s, with a Western Union and hotel on the left. A Joseph's Pharmacy with a Coca Cola sign is on the right. Two more buildings visible and adjacent to the pharmacy were the Mayers and F.W. Woolworth's 10¢ store.

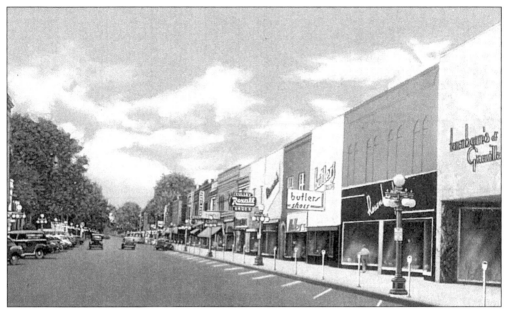

A view from a few years later shows how some of the stores had changed. The Culley Rexall Drug Store seen in this postcard was near the same location as Joseph's Pharmacy in the previous postcard. This postcard was published between 1930 and 1945.

This postcard shows some of the east end residences on Washington Avenue in the early 1900s in Greenville. A postcard addressed to Miss Maria H. Starling, daughter of Lyne Starling, had her address on Washington Avenue in 1907. Another postcard sent to Maria H. Starling in 1905 was addressed to Ms. Joe Hensley, her grandmother, in Louisville, Kentucky. She was the daughter of Lyne Starling and the niece of Maj. William Starling, all of Greenville.

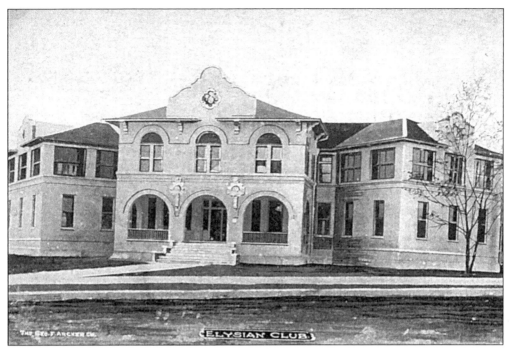

Shown here is the Elysian Club in 1906. A handwritten message says, "Aug1-06, Mrs. T-You are cordially invited to attend the grand ball here this evening. Carriage will call for you promptly at 8.30. Ask you pa if Tim may go?"

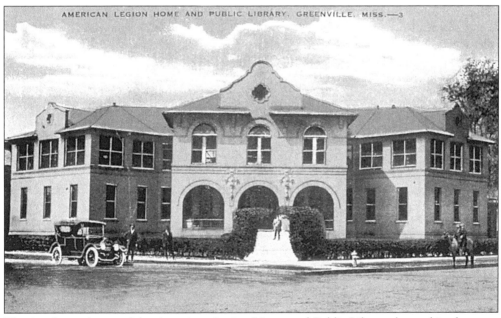

This is a later picture of the American Legion Home and Public Library, located in the same building pictured in the previous view.

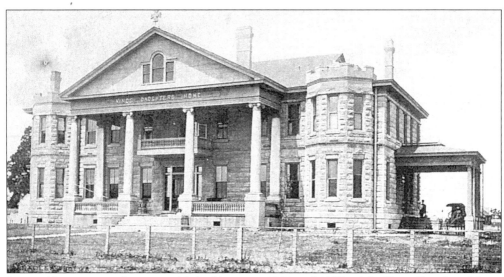

Pictured here is an early view, published between 1901 and 1907, of the Kings Daughter Home in Greenville. The building opened in 1894 with 25 beds.

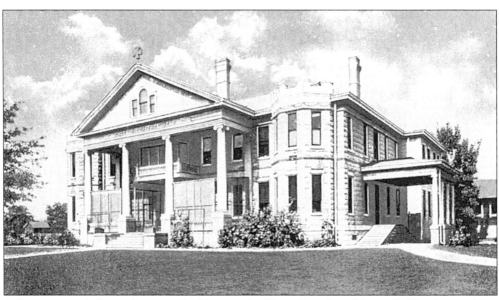

A later postcard shows this same building as the Kings Daughter Hospital. This hospital has added newer buildings, increased capacity, and continued as a hospital into the late 1900s.

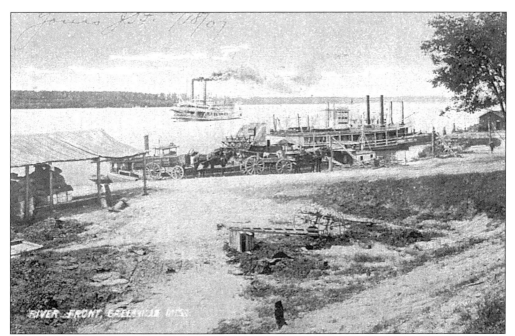

This postcard shows a 1907 view of the riverfront in Greenville. Dr. James Hunt, who married Prudence Blackburn of Kentucky in 1836, was one of the earliest promoters of a levee system to protect the city of Greenville. That system worked until 1927 when the city was flooded.

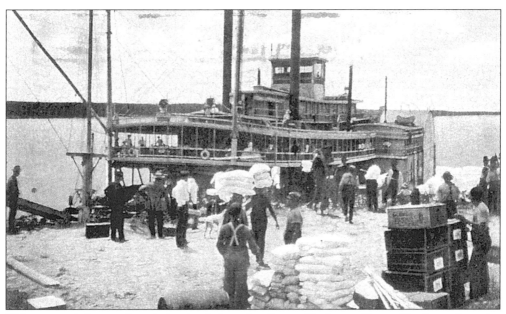

This postcard shows a boat being loaded on the Greenville levee. Greenville, located on the Mississippi River, became the capital of the levee district. Levees were built along the river to protect towns such as Greenville from flooding. Maj. William Starling became chief engineer of the Mississippi Levee District for many years after 1884, while his brother, Lyne, settled in Greenville. Their parents were from Kentucky.

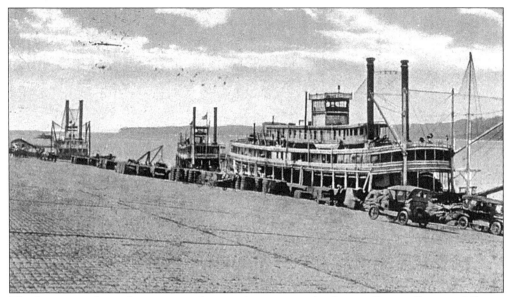
This later view shows the same riverfront with a concrete landing in Greenville, very different from the waterfront of 1907.

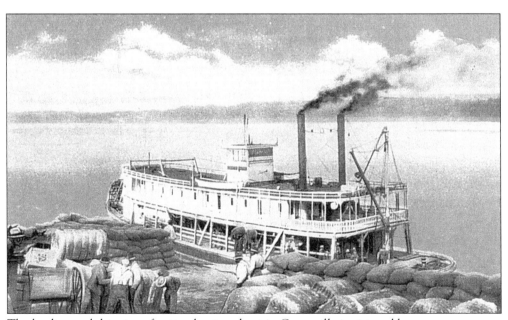
The loading and shipping of cotton by steamboat in Greenville is pictured here.

The next two towns are too small to be found on our 1950 map and are south of Greenville in this northwest part of Mississippi. This postcard, from around 1905, shows the main street of Arcola, Mississippi. Arcola has never developed into a large town.

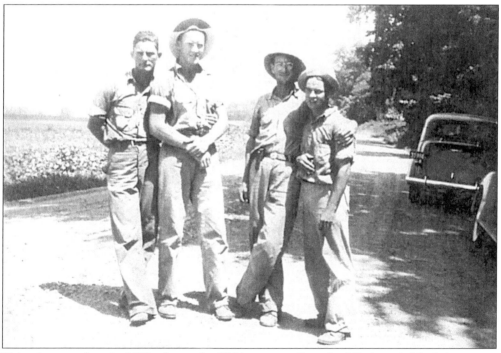

This picture, taken in 1937, shows the TVA crew at Satartia, Mississippi. My father was a member of that crew and was second from the right. Although this crew was mostly assigned to the northeastern part of Mississippi, they had gone to Satartia (and had a picture made) for consideration of a TVA job. Sataria has, also, never developed into a large city.

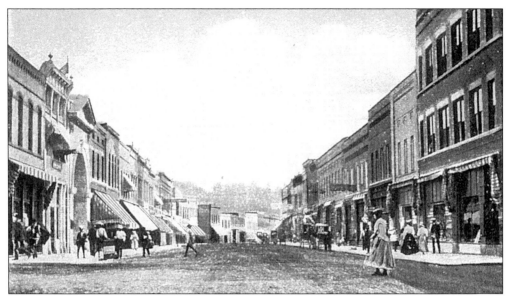

Yazoo City is the last town in this northwest part of Mississippi available on old postcards. This postcard, published between 1907 and 1914 of Main Street in Yazoo City, is looking south from Brown's corner on an unpaved street. In 1904, a devastating fire destroyed 324 buildings, including nearly every business and industry. The city was rebuilt within one year, and this picture was after the fire.

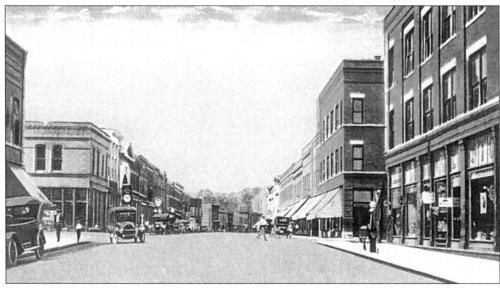

This postcard of the same view several years later shows a paved street. The corner buildings on the left are similar to the buildings on the left of the previous picture, while others have changed significantly.

Three
JACKSON, THE CAPITAL OF MISSISSIPPI

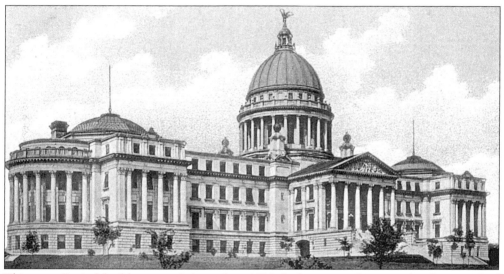

This new Capitol building was dedicated in 1903. Jackson was chosen to be the capital of Mississippi in 1821 because it was in the center of the state and on a navigable stream, the Pearl River. There remained a question as to whether Jackson would remain the capital until 1850, when it was accepted as the permanent seat of government. By the late 1800s, Jackson had developed into a major railroad center of the state. The Illinois Central Railroad running north and south from Chicago going through Jackson to New Orleans and the Vicksburg & Meridian railroad running east and west and going northwest to Helena, Arkansas, and running southwest, northeast to the coal fields of Alabama, all made Jackson an important link. Jackson had at least 500 buildings and all the important state and Federal institutions necessary for government by 1900. The governors who brought the State through the recovery period after the Civil War had been Confederate soldiers. The state had continued in the same previous economic pattern of cotton and lumbering. It was crushed by the Depression of 1932. A change in Mississippi leadership was needed at this time. It came in 1936 when a new administration started expanding resources for new industrial development, increasing farm production through diversification of crops and creating the first major highway construction program for Mississippi. These changes effected every citizen by the middle of the 1900s. However, it was World War II that made Mississippi a beehive of military activity. The war boom gave Mississippians more money to spend than ever before. The state had established itself as an industrial source by the middle of the 1950s.

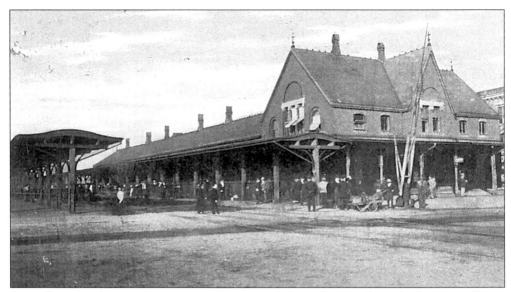

Since the railroad was such a major source of growth for Jackson in the early days, we will start with pictures of the railroad station on Capitol Street. In 1888, the Illinois Central Company built a passenger depot in Jackson unsurpassed by any in the south, and a grander building was added to this important railroad center by 1891. This postcard from c. 1907 shows the Illinois Central Railroad Depot, later called the Union Depot, in Jackson. To keep traffic from crossing the path of the train, there was a gate, which can be seen in this postcard, to stop horses, buggies, and people who used the street and walkways.

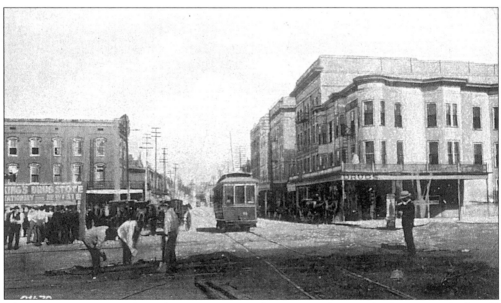

This opposite view east from the Union Depot shows Capitol Street looking towards the old Capitol Building. On the left is King's Drug Store, and on the right is the Edwards House.

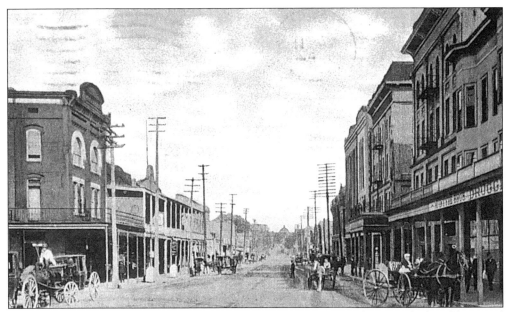

This view shows Capitol Street looking east from the railroad tracks towards the old Capitol Building at the end. The postcard was postmarked 1911 and had a handwritten message that read, "we have fine buttermilk, have horse and go driving everyday."

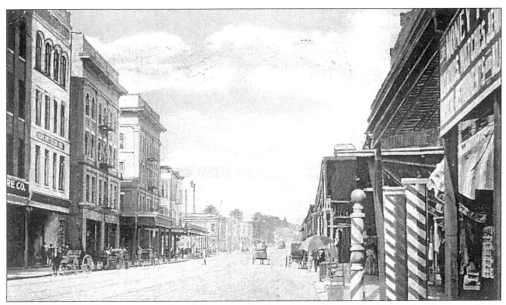

This view from the opposite side of the street looking west shows the Edwards House and the railroad gate on the far left. The postcard has a 1908 postmark.

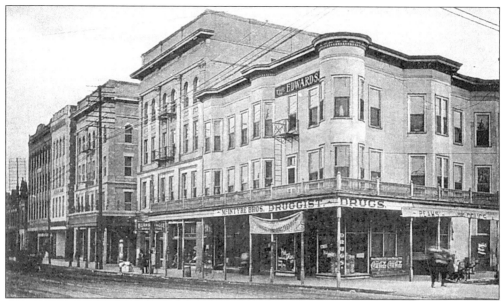

This postcard, published between 1901 and 1907, shows a closer view of the McIntyre Drug Store in the front of the Edwards House on the right side of Capitol Street, facing east.

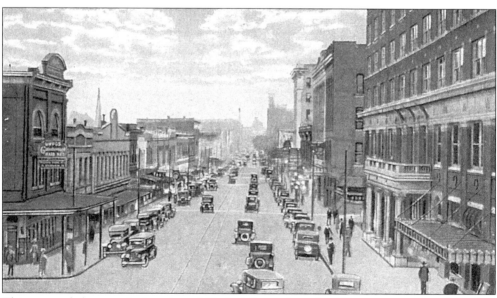

This postcard shows a similar view of Capitol Street but of a different time, around the late 1920s. The Edwards Hotel is still on the right, after having been renovated in 1923. The tall building on the right, the Lamar Life Building, was built in 1926. Its unique architecture with the clock tower has made it one of the city's landmarks.

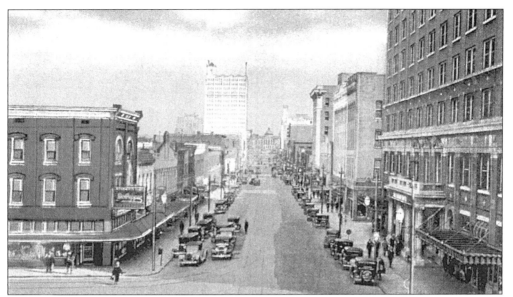

The same view captured a few years later shows the changes on Capitol Street in the 1930s. The tall building on the left began as the new Merchant's Bank Building, but it closed in 1933, and Deposit Guaranty Bank purchased the building in 1937.

Looking east toward the old Capitol, Capitol Street is pictured on this 1942 postmarked postcard. Another hotel can be seen between the furniture store and the Lamar Life Building on the right. The Heidelburg Hotel added ten more floors in 1937.

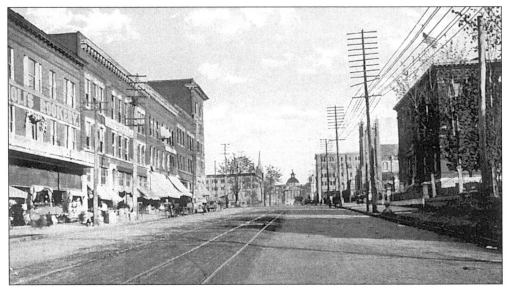
Moving east up Capitol Street towards the old Capitol Building, this postcard view was published between 1901 and 1907. The old Federal building and post office is on the right with St. Andrew's Episcopal Church located next door. Buildings on the left are featured in the next postcard.

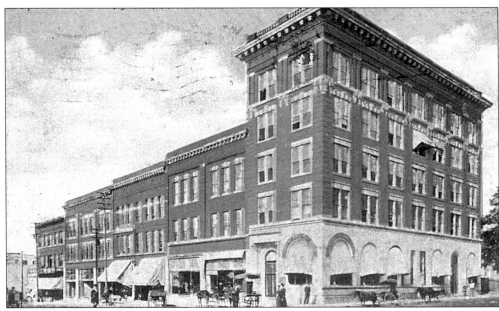
This postcard shows the Capital National Bank on Capitol Street that was built around 1905. Late in 1949, the Capital National Bank and the Jackson State National Bank merged to form the First National Bank, and a new building was raised for it, and the buildings shown here were torn down.

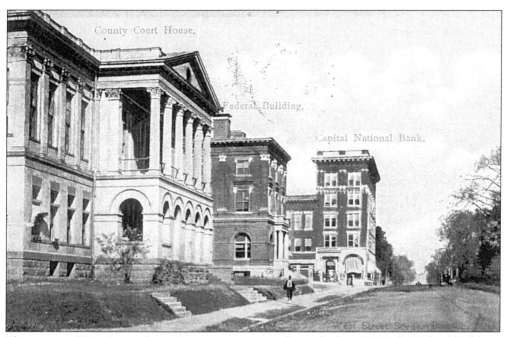
This view on West Street shows the new county courthouse built in 1902, the Federal building, and the Capital National Bank across Capitol Street.

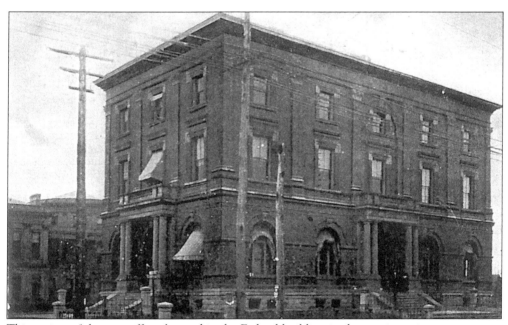
This a view of the post office, located in the Federal building in the previous picture.

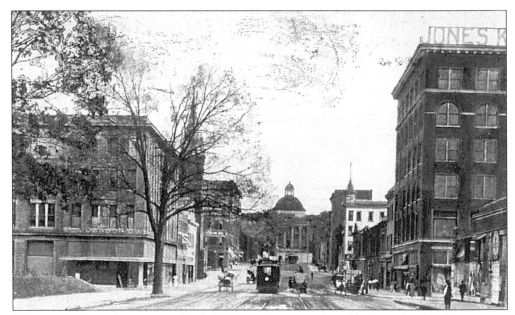

This postcard, with a postmark if 1908, is closer to the old Capitol with Kennington Department Store on the right. On the left is the S.J. Johnson Store, which later became The Emporium. A water wagon is flushing the street and passing a trolley in the center of the photo.

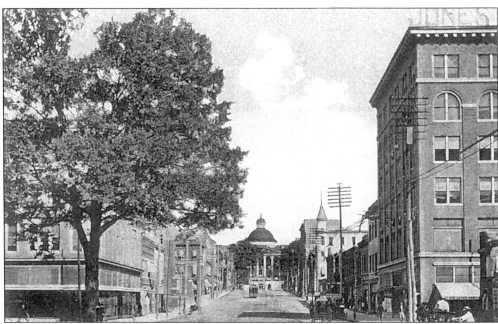

This postcard, with a postmark of 1910, shows a similar view of Capitol Street. Notice the left tree is larger, and a utility pole is pictured on the right, different from the earlier view.

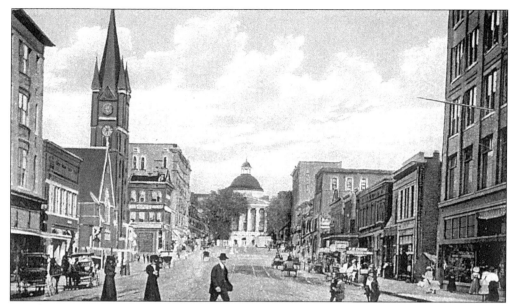

Another view can be seen facing the old Capitol including Kennington's Department Store on the right and the First Baptist Church Building on the left. A handwritten message compared the old Capitol to the new one built in 1903 by saying, "The new one is certainly pretty."

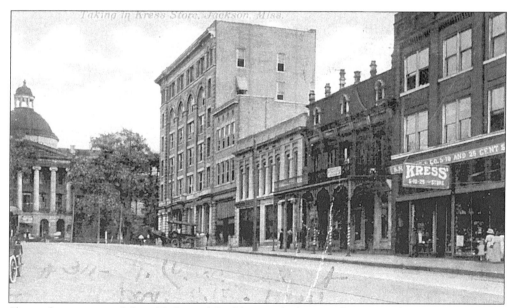

Shown here is part of the old Capitol Building with the Merchant's Bank on the corner and Kress 5-10-25 ¢ store on the south side of the 500 block of Capitol Street. The barber poles are in front of Holbert's Barber Shop.

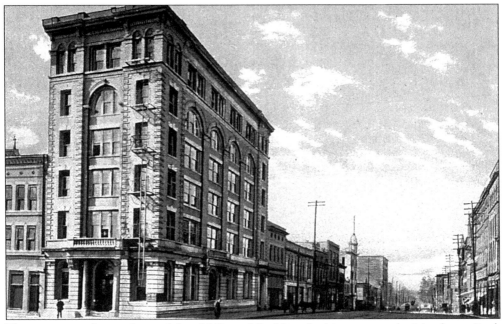

This view was taken in front of the old Capital Building, looking west at the Merchants Bank Building on the south side of Capitol Street.

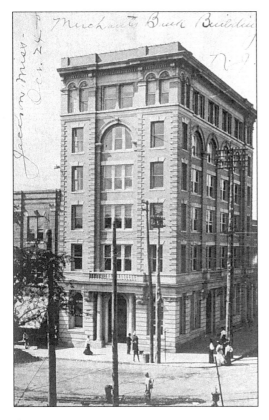

The Merchants Bank Building across from the old Capitol Building is pictured on October 24, 1906. The director of Mississippi highways from 1932 to 1945, Edgar Kenna, had formerly been the executive vice-president of this bank.

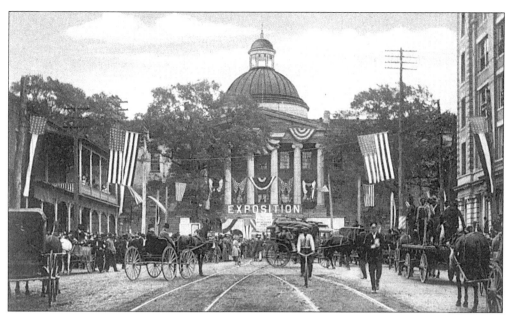

This view shows a close picture of the old Capitol Building, which was first occupied in 1842. As the center of state activity for more than 60 years, this building was the location of many historical events such as Andrew Jackson addressing the legislature in 1840, Henry Clay speaking in 1844, the Ordinance of Succession passing in 1861, and the governor being arrested in 1865. The building was spared by the federal troops during the Civil War. In the early 1900s, when a new capitol was constructed, this capitol building was condemned and abandoned. It has since been renovated into a museum.

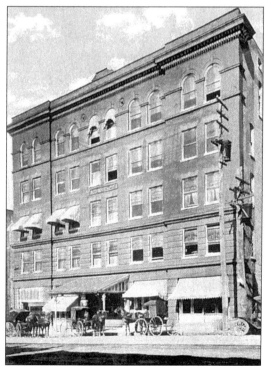

This postcard shows the Century Theater and Office Building in Jackson. It was the entertainment center of the city for several decades until it was razed for a parking lot in 1963. Inside, the ornate theater had three balconies overlooking a large stage.

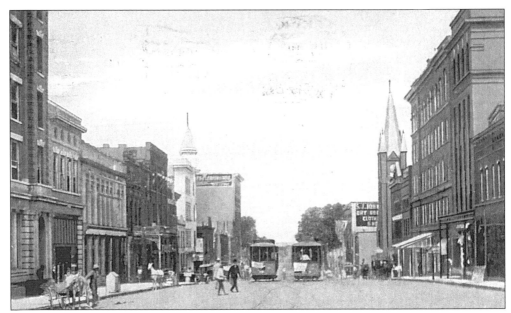

Looking west down Capitol Street, the Century Theater is the third building on the right. The First Baptist Church and the S.J. Johnson Dry Goods Building, later known as the Emporium, are further down on the right.

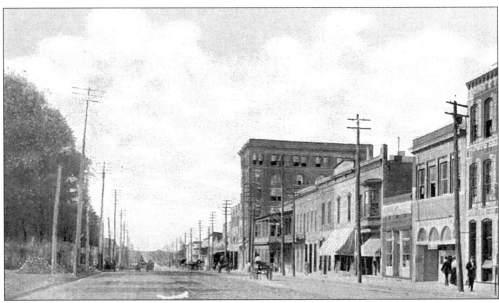

This view is looking south on North State Street, one block north of Capitol Street. A 1910 city directory identified the following businesses on Capitol Street: (on the right) the Tucker Printing Company, Jackson Theatorium, Sherman Grocery with Dr. Lewis and Bartlett upstairs, and Hall-Mosal Paint and Glass Company; and (on the left) the tall building, Merchants Bank. The grounds of the old Capitol Building are on the left.

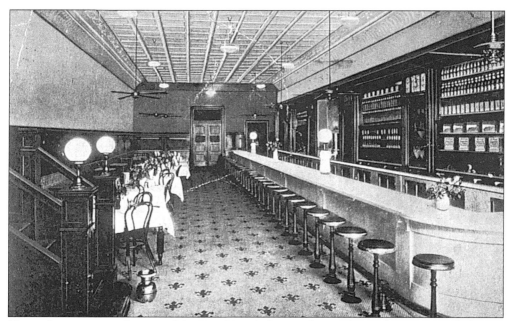

Shown here is an inside view of the Bon Ton Cafe in Jackson. The card was postmarked 1914 and had a message from R.L. Sterling to J.D. Sterling in Madison, Mississippi, stating that he was visiting his sister. There were several Sterling family postcards sent to Mr. J.D. Sterling in Liberty, Mississippi, with postmarks of 1910, at 712 West Capital Street, Jackson in 1917, and the address of Box 536, Biloxi, Mississippi, in 1924.

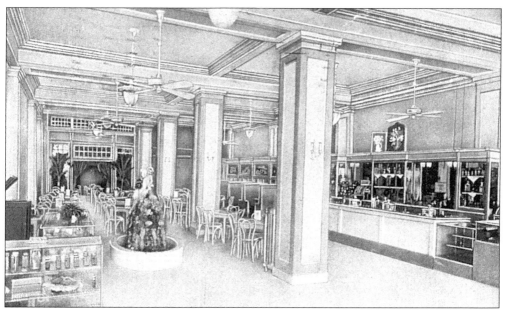

The Mecca Confectionery and Tea Room was designed and installed by Westbrooks Manufacturing Company in Jackson. It was a popular soda fountain on Capitol Street around the 1920s.

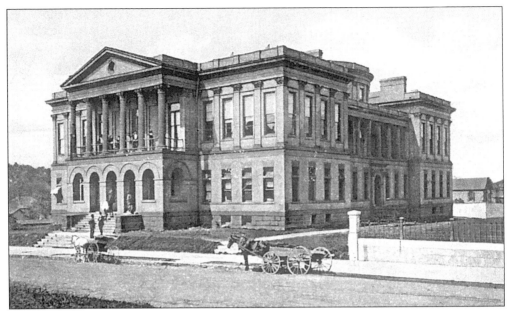

This postcard shows a different view of the courthouse in Jackson. It was razed in 1931. See page 55 for another view.

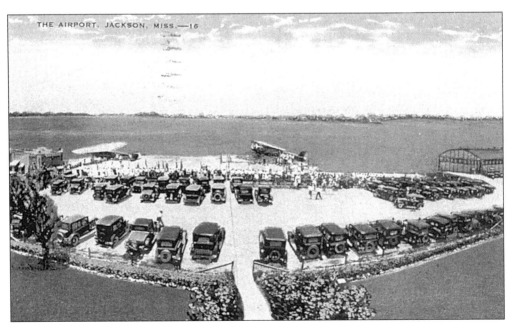

This is a view of Hawkins Field inaugurating north-south mail service through Jackson in June 1931. Hawkins Field was Jackson's first airport and was dedicated in 1928. It continued to serve the city until another airport devoted to the larger jets was opened in the late 1900s.

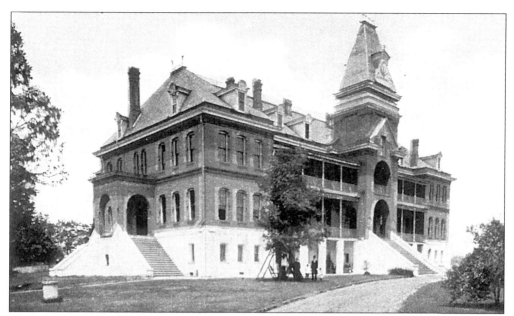

The Blind Institute of Jackson opened in 1881 on North State Street at Fortification. It continued to operate at this location until 1951 when it moved to a new location on Highway 51, North and Eastover Drive.

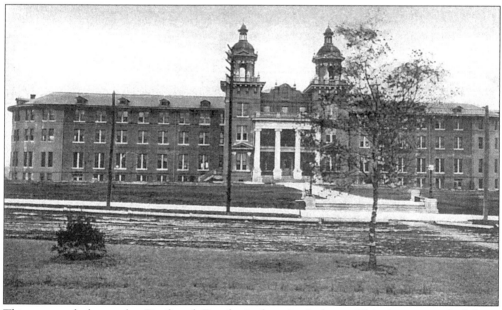

This postcard shows the Deaf and Dumb Asylum in Jackson. This institution had been established in 1854 but was destroyed during the Civil War. It was rebuilt, and that facility was destroyed by fire. This new building was opened in 1905 at 1448 West Capitol and continued in operation until 1951, when it moved adjacent to the new school for the blind.

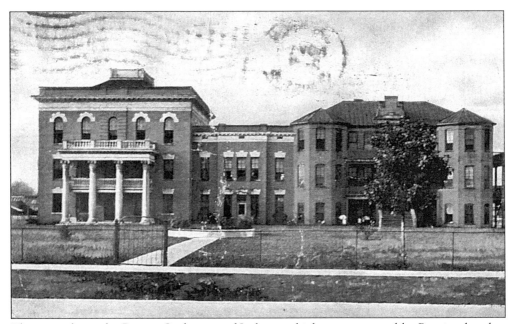

This view shows the Baptist Orphanage of Jackson, which was supported by Baptist churches throughout Mississippi. The postcard was postmarked 1909.

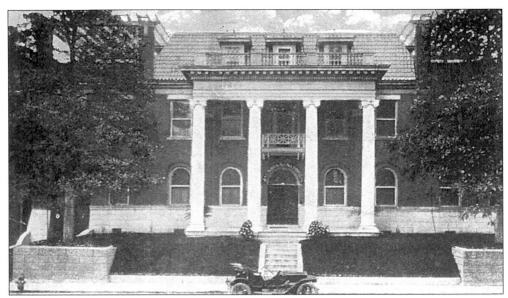

The Jackson Sanatorium opened in 1902 with 20 beds. It was consolidated with the Jackson Infirmary in 1924, and the Jackson Infirmary was sold to the Order of Dominican Sisters in 1946.

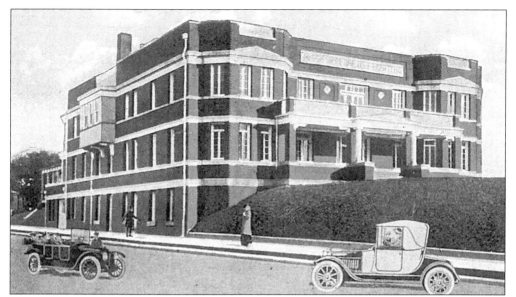

This postcard shows the Baptist Hospital of Jackson. It was opened in 1909 as the Hunter-Shands Hospital, a private institution, but changed to the Baptist Hospital in 1912.

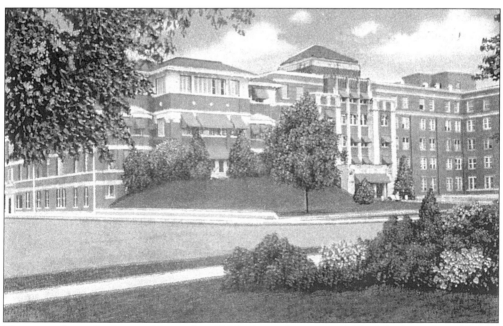

This view shows the Baptist Hospital in 1954 when it became a 400 bed facility, after additions were made in 1929.

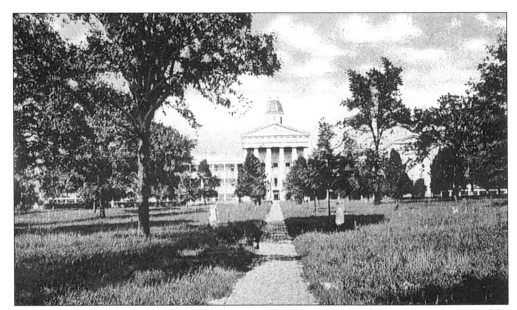

This hospital in Jackson is pictured here between 1907 and 1915. It opened in 1855, and by 1891, there were 471 patients. In 1912, the capacity of the hospital had been extended to 1,350, and the name was changed from State Lunatic Asylum to Mississippi State Insane Hospital, typical of most state mental hospitals of that time. Notice the brick sidewalk that remained there at least until 1965, when this author worked at the University of Mississippi Medical Center and would often follow parts of this brick sidewalk.

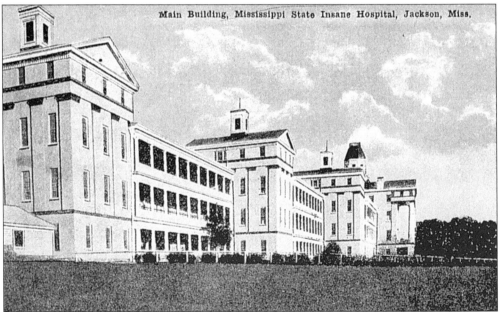

This early 20th century postcard shows the main building of the Mississippi State Insane Hospital. A new hospital at Whitfield, Mississippi, was opened in 1935, and the move from the old North State Street location in Jackson was completed in nine days. By 1955, the Whitfield facility had grown to a capacity of 4,000 patients. The University of Mississippi Medical School and Hospital was opened on this site in 1955.

Four
HIGHWAY 80 WEST AND WEST OF PEARL RIVER

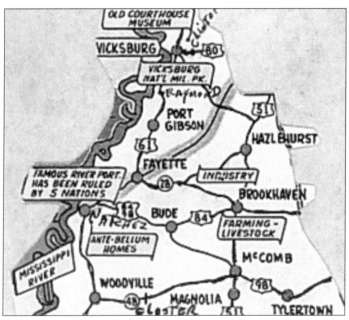

This section of Mississippi will start on Highway 80 west with small towns such as Clinton and Edwards but will also include Vicksburg, the third largest city from 1910 to 1940, and continue south. While devastated by the Civil War, local citizens begin to realize by the early 1900s that their battle grounds and antebellum homes could become a source of tourists income. Unfortunately, the Mississippi roads were bottomless quagmires in the winter season, and the county roads did not connect with other roads, limiting travel throughout the state to times of good weather. Tourists traveling to the South avoided Mississippi. Although, by 1925, Mississippi was maintaining 2,632 miles of roads and had financed additional miles from Federal funds, it was not enough at the time. Highway development became a priority in 1936. Automobile travel throughout the whole state became possible by the middle of the 1900s, and tourism increased. Mississippi College, the state's oldest college now in existence, was organized as the Hampstead Academy in Clinton, Mississippi, in 1826. In 1850, the college was affiliated with the Baptist church. The majority of its 200-person student body left for the Civil War, to return after. The college has continued to serve the Baptist and surrounding counties of Mississippi. We will start with some postcards of Mississippi College in Clinton.

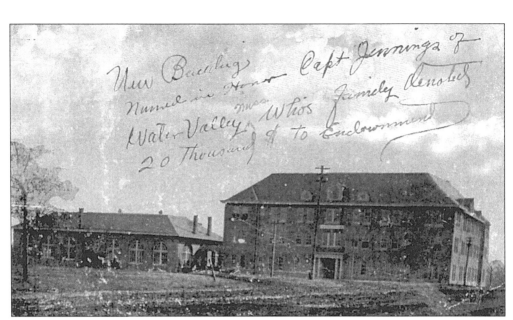

In this early view of Jennings Hall at Mississippi College, the sender wrote a message, "New building, named in honor of Capt. Jennings of Water Valley, Mississippi who's family donated 20 thousand $ to endowment." The postcard was sent in 1909. These building were still a part of Mississippi College in the 1950s.

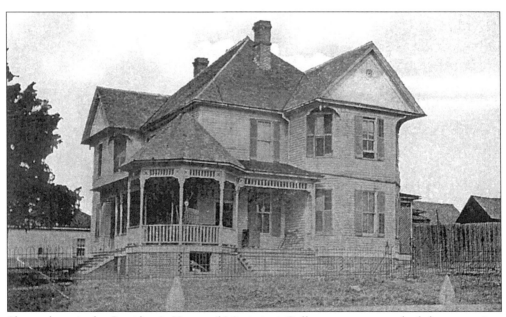

Shown here is the President's Home of Mississippi College on a postcard of the same time period as the previous view of Mississippi College. The President's Home was not present in Clinton, Mississippi, or at Mississippi College by the 1950s.

This postcard from the 1950s shows Nelson Hall, an administration and chapel building. This building was still part of the college in the late 1900s.

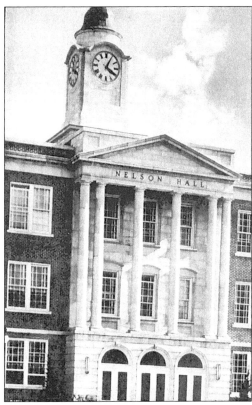

Jefferson Street in Clinton is pictured here around the 1920s. The author spent her late childhood and adolescence in Clinton through the 1960s. The view of Jefferson Street had changed so much by the 1950s that this view was not familiar. Downtown Clinton is further down the road.

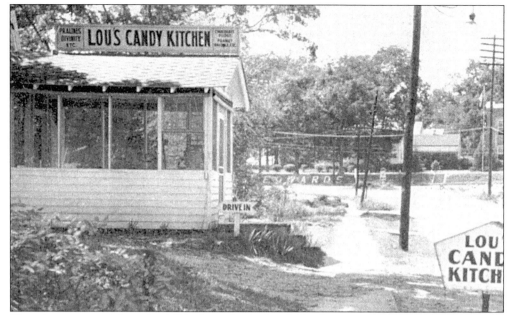

This photo postcard from the 1930s shows Lou's Candy Kitchen in Edwards, Mississippi, on the "Sweetest Spot on Highway 80" West. The candy kitchen claimed to be famous for delicious divinity, chocolate and caramel fudge, date loaf, pecan pralines, and peanut brittle. Mail orders were possible. The town name, displayed in the center of town, can be seen in this picture.

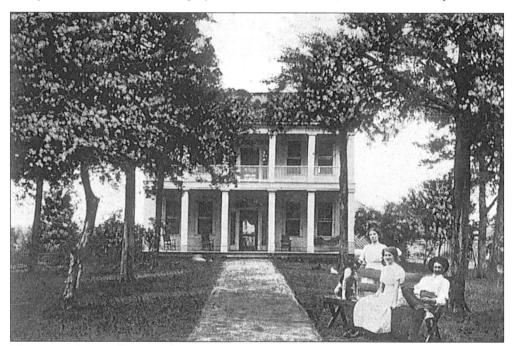

This postcard view of Raymond, Mississippi, postmarked 1916, shows Hubbard's Mineral Well. Identified on the postcard in Jackson, Mississippi, was W.L. Brown, the agent for Hubbard's Mineral Well. These last two images demonstrate how postcards were used to encourage tourism.

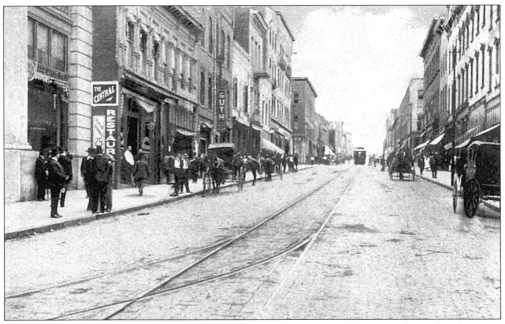
The next 15 postcards are views from Vicksburg, Mississippi. This one shows Washington Street looking south c. 1907.

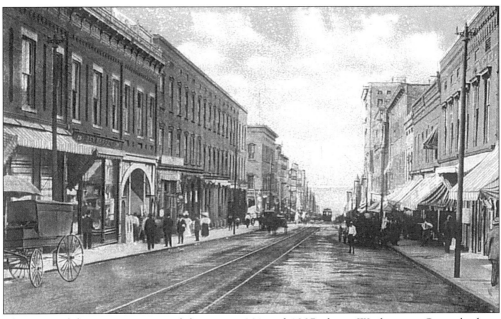
This view of the same time period, between 1901 and 1907, shows Washington Street looking north.

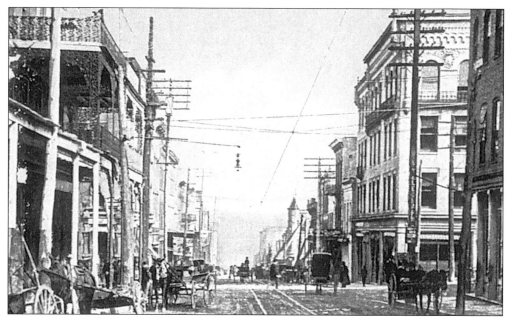
This postcard, created between 1915 and 1930, shows Washington Street going down to the Mississippi River. Many of the streets in Vicksburg descend down to the waterfront.

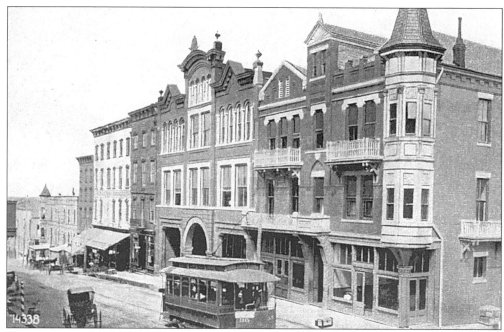
Clay Street and a trolley car are shown in this early 20th-century view. Notice that the unattended trunk on the sidewalk and the building on the corner appear to be empty.

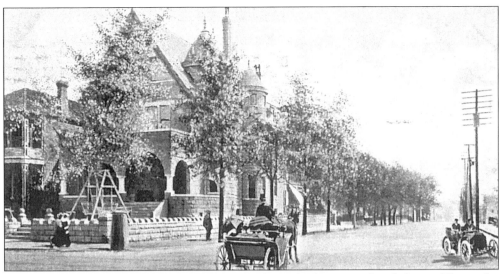

This view, with a handwritten date of 12-31-06, shows the homes on South Street. The sender wrote, "Please exchange for a colored street or park scene, Julius Weil," which was typical of postcard collectors requesting postcards.

This postcard, with a handwritten date of 7-12-09, shows the Vick Homestead used as a hospital during the Siege. A handwritten message states, "This is the view of the old home of the Vick family, after which our city was named. It was destroyed a short time ago to make place for a $40,000 modern residence of a newcomer-a Mississippian, however, who had made his money in cotton, GMK to Mrs. Arthur Goffman." "GMK" was George Marion Klein, who is referred to on several postcards of Vicksburg. He was born in 1844 and died in 1923. He married Louise H. Balfour on July 30, 1868, and in 1909, when he wrote to Mrs. Goffman, he was 65 years old.

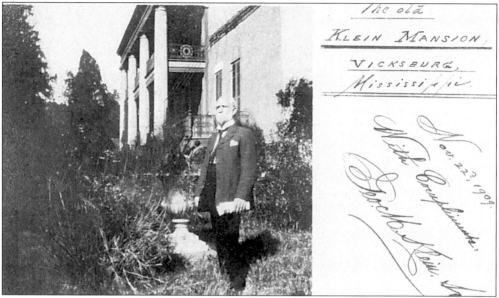

This photo card taken of Geo. M. Klein Sr. and dated November 22, 1909, is very unusual. It shows him at the old Klein Mansion, and he wrote a message to Mrs. Coffman on the back: "I thought it might possible interest you to see how your old southern friend looked. This residence was built by my father John Alexander Klein nearly sixty years ago. It was over these grounds that the first shell that was fired into Vicksburg as the Civil War exploded. It was shot from the gun boats below the city, which had come up the Mississippi River from New Orleans. This place was once a plantation, it is now in the heart of the city. After the surrender in 1863, it was used for a military hospital; but was soon afterward restored to my father, when he returned from his plantation, to which place he had taken his family during the Siege. I was 'inside' a boy artillery sergeant. Sincerely."

This is a 1950s postcard of the same Klein Home that continues as a bed and breakfast facility. The author visited that home in 1988 and gave a copy of the previous postcard to the current owners, who had no knowledge of it.

Shown here is the northeast entrance to the National Cemetery and Park at Vicksburg in a c. 1907 view.

This view of the same time period shows another entrance to the National Military Cemetery and Park.

The Iowa Monument in the National Cemetery and Park is depicted in this postcard, but what is more interesting is Geo. M. Klein's handwritten description dated 7-12-09: "This is a perfect gem of art in single bronze figure by a woman sculptor, Mrs. Henry Hudson Kitson, the wife of the Boston sculptor, who designed our beautiful, Iowa State Monument, in the Military National Park here. Its pose is most lifelike and workmanship of great excellence."

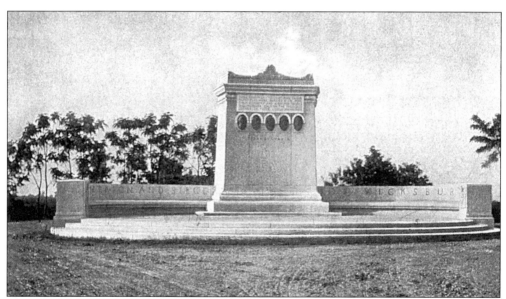

This is another postcard of the Pennsylvania Monument. Geo. M. Klein's handwritten description, dated 8-24-09, stated, "The inscription on the Pennsylvania Memorial is the following appropriate and noble sentiment. Here Brothers fought for their Principles. Here heroes dies for their country and a United people will forever cherish the precious legacy of their noble manhood. That is a grand expression: isn't it?" The postcard shows this picture of the Pennsylvania Monument at the Vicksburg National Cemetery and Park.

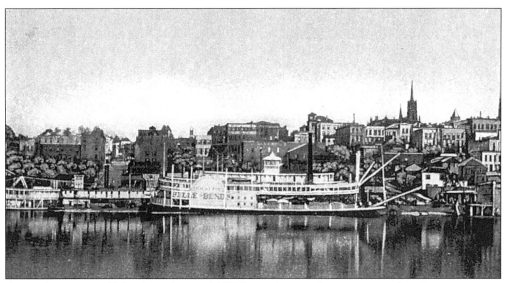
A riverfront view of Vicksburg from c. 1907 shows the courthouse among churches.

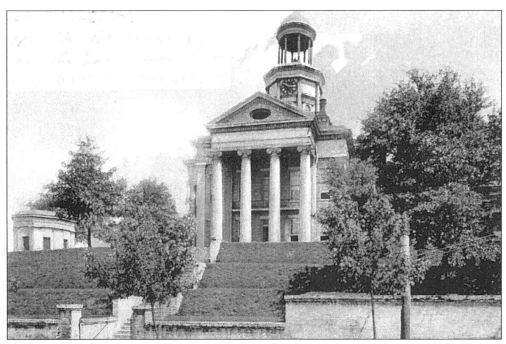
This is a view of the courthouse, postmarked Memphis, Tennessee, on August 30, 1907. A short note was handwritten, "Come up on the boat, had a miserable trip, arrived this morning."

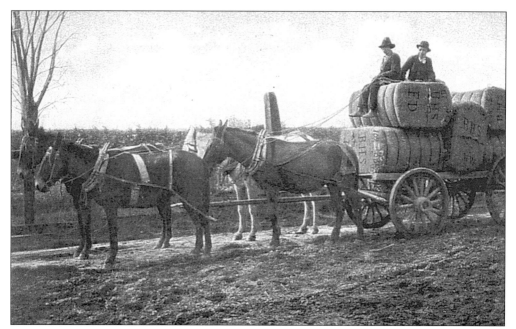

The last two postcards of Vicksburg will show the road conditions in that area from around 1901 to 1907. This postcard shows the dirt road going to the cotton market and how the bales of cotton were marked.

This road, Warrentown Road, was an early route, unpaved and narrow, towards Jackson before Highway 80.

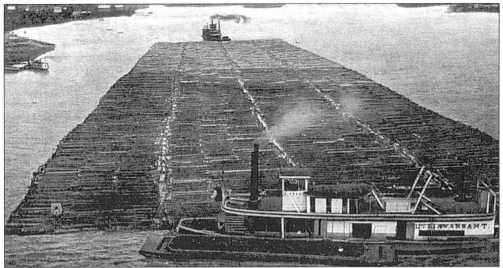

Depicted here is a raft, called a log drive, transporting large numbers of logs in the early 1900s on the Mississippi River. Each landowner, chopper, creek runner, or drive foreman would mark his logs with his own brand, and loggers would herd their bawling, bumping charges down the river or stream to a lumber mill. Ten to fifteen logs were banded together to form a crib, and a number of cribs formed a raft. At the mill, the buyers would break up the rafts, read the brands, and pay the loggers accordingly.

This family postcard, c.1905, was taken of three young people with the handwritten message, "This one was taken in Jackson at the fair, when I went over with the college girls.". Identified was Miss Magruda Golden (on the left), who later became Mrs. Edward Thompson and died in 1918, and Miss Carrie Golden (on the right), who became Mrs. Camp Wheeler and died in 1974. The other person, "Kommom" Lobster, was their driver. Both women were attending the Port Gibson Female College, founded in 1843. Mrs. Wheeler was the grandmother of Judge J.W. Deese, husband of the author. Port Gibson is south of Vicksburg and north of Natchez.

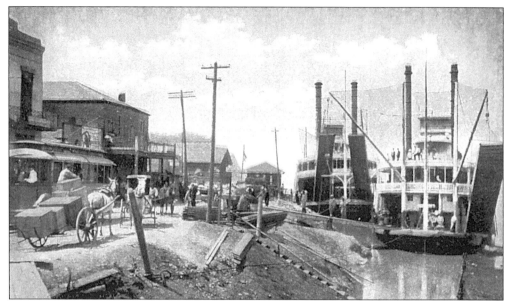

The next town we will explore is Natchez, which was not marked on the 1950 map but was identified as the famous river port that has been ruled by five nations. This is a c. 1907 view of a steamboat landing under the Hill in Natchez. The Hill was a 200-foot bluff above the river that contained residences, while the base was the waterfront where the shipping business occurred.

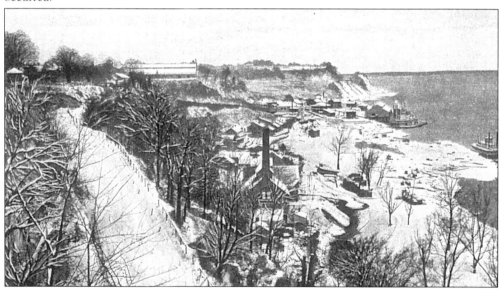

This c. 1907 view depicts a steamboat landing under the Hill in Natchez. Notice that snow appears to be on the ground, which was unusual for that section of Mississippi. Another unusual connection occurred between Dr. A.H. Brenham, a Mississippi state senator from 1879 to 1887, and Dr. L.P. Blackburn, who was governor of Kentucky from 1879 to 1883. Both were trained at the Transylvania Medical School in Lexington, Kentucky, and they practiced medicine together in Natchez from 1849 to 1853. Dr. Brenham named his only son, Luke Blackburn Brenham, for his friend from Kentucky. Luke Brenham continued to manage the extensive family real estate holdings in Natchez.

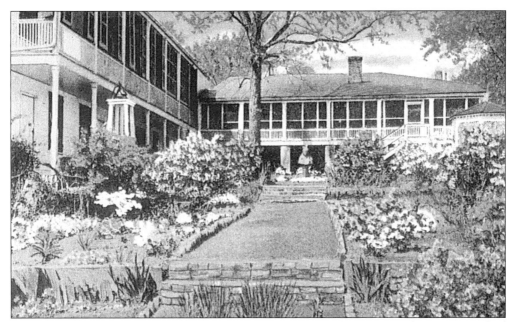

This postcard, c.1930, shows Hope Farm. Mrs. J. Balfour Miller, owner of Hope Farm, had developed the idea of opening her home for a Garden Club Convention. This started the Natchez Pilgrimage that spread throughout this part of the state and provided income through tourism.

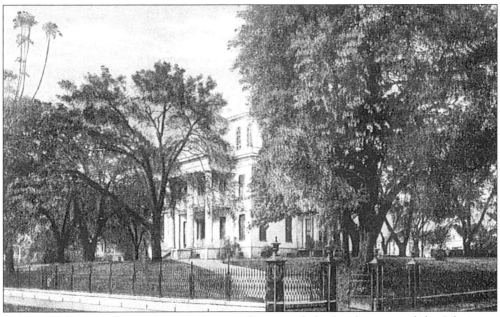

Stanton Hall, one of several antebellum residences and the headquarters of the Pilgrimage Garden Club, is pictured here c.1930. Postcards of this era had preprinted messages on the back describing this property, such as the fact that Staton Hall was built in 1851. Mrs. Carrie Golden Wheeler, after becoming a widow, worked for a period of time in Stanton Hall as a hostess.

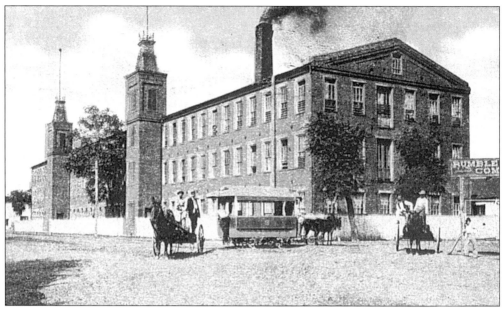
This final postcard of Natchez shows a cotton mill in 1910 with part of the name "Rumble Company" showing.

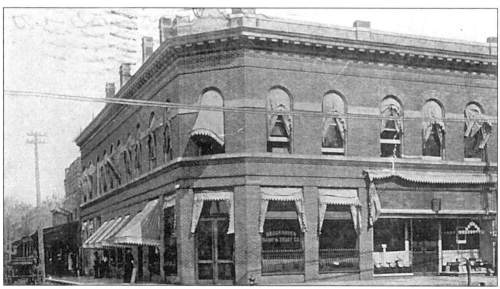
Continuing east from Natchez we find Brookhaven, Mississippi. This postcard shows a c. 1907 view of the Brookhaven Bank and Trust Company. Brookhaven is located on old Highway 51, south of Jackson.

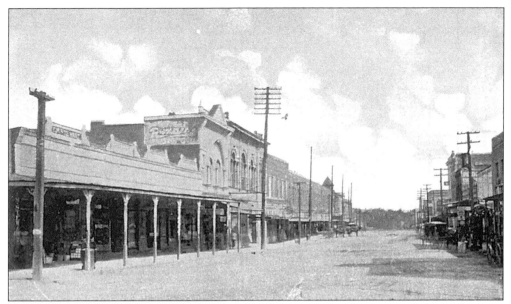

South of Brookhaven on Highway 51 is McComb, Mississippi. This postcard shows the main street of McComb in the early 20th century. During this time, McComb became an important railroad terminal and repair center on the Illinois Central Line. About 1,500 employees worked in the terminal repair center in 1911. There were strikes that year, and in 1922, a strike resulted in many employees losing their jobs and caused financial turmoil to the area.

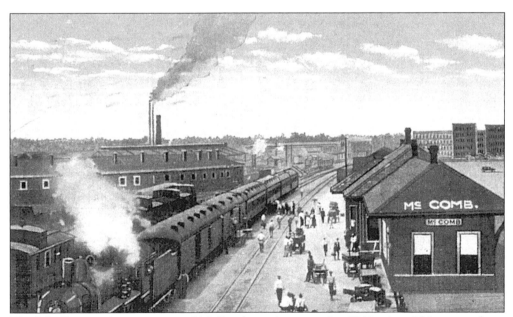

The I.C. Shops and train station of McComb are shown in this 1940s view. This postcard was sent to the parents of Pvt. Harold Frantz in Toledo, Ohio, from Camp Van Dorn, Mississippi, southwest of McComb. This camp was one of the several that dotted Mississippi during WWII.

Continuing west from McComb is Gloster, Mississippi. This postcard, with a handwritten date of October 27, 1906, shows the main street of Gloster. A crowd of people have gathered around the W.R. Williams Hardware and Electric Store on the left. Utility poles and the street light confirm some type of electric power at this time.

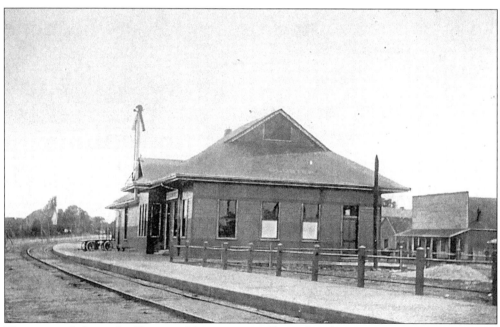

This postcard shows the Yazoo and Mississippi Valley railroad station at Gloster, Mississippi. This postcard, postmarked 1908, was sent to Miss Nan Crawford of Tylertown, Mississippi, about 20 miles southeast of McComb.

This postcard of the same era shows the Bank of Gloster with a handwritten note, "my school closes the 17th I will go home Sat. Hope to see you soon." Above the bank was an insurance agency and Dr. H.H. Street.

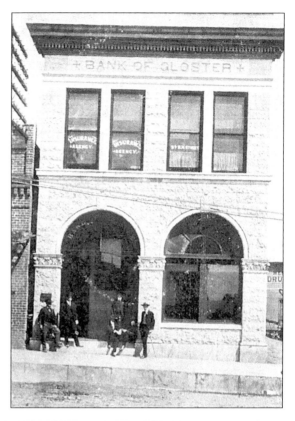

We continue traveling southwest to Woodville, Mississippi. This c.1930 view shows a greeting from Woodville with a car, horse, and buggy on what they described as one of Mississippi's modern highways. The picture shows a two-lane paved road and emphasizes the good roads in the state. It compares the older (horse and buggy) with the newer (car).

This postcard from the 1940s shows the Major Feltus Home in Woodville. This postcard was made by Martin's Drug Store in the same town and claimed that the home was over 100 years old. Again, this postcard was part of a trend of attracting tourists.

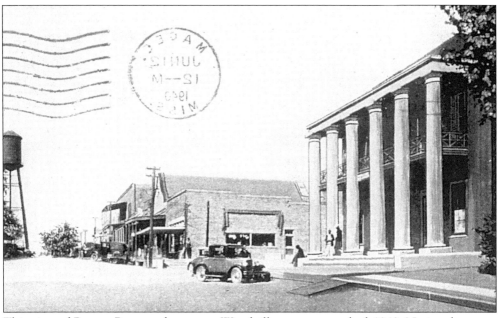

This view of Boston Row, or downtown Woodville, was postmarked 1940. Notice the water tank and cars. Woodville is the last town of this southwestern part of Mississippi.

Five
HIGHWAY 80 EAST AND EAST OF PEARL RIVER

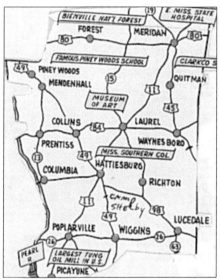

This southeastern section of Mississippi, starting along Highway 80, includes Meridian, the largest city in Mississippi until 1920. Also in this section is Hattiesburg, the "capital" of a lumber empire in 1912, and a military post 10 miles from Hattiesburg, deactivated after WWI and activated for WWII, all influencing the local economies.

However, in the early 1900s, most of this section was rural and consisted of two types of farms, the family farm and the share-renter farm, different from the large plantations around the northwest and southwest part of Mississippi. The family farm was the self sufficient unit with the family supplying some of the labor and/or hiring out the labor and selling their extra produce for income, while living off their products. The family farm was typical of the Scott family farm in Lucedale, where their food was grown on the farm. Extras, such as college tuition for each child, was gained by selling timber. All six children graduated from college during the Depression. Such was not typical of the average Mississippi family. Although they had to have "made over" clothes because money was scarce during the Depression, they fared better than most Mississippi families at that time.

The Scott family had a postcard collection that has been handed down to this author. Unfortunately, the grandchildren were allowed to play with the postcards, and most were in poor condition. However, the messages on those old postcards still provide forgotten information about the family.

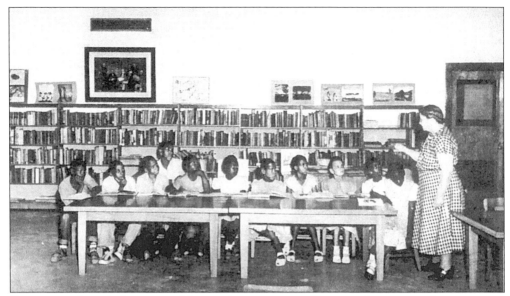

Our musing through the towns of this southeast section will start in the most northern part, just south of Jackson, at a school in Piney Woods, Mississippi. This postcard shows an inside view in the library of the school in the children's room at story hour.

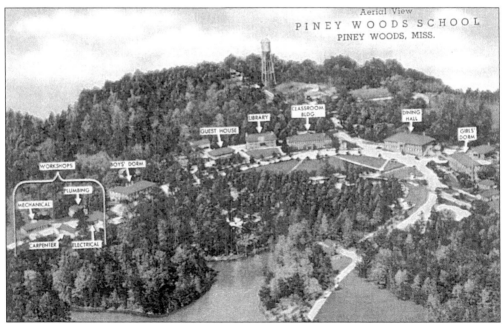

This is an aerial view of the Piney Woods School, established in 1913 by Dr. Laurence C. Jones.

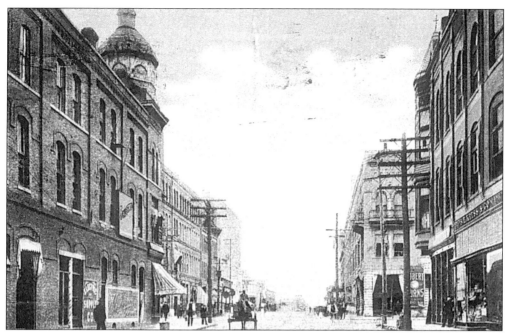

Going east on Highway 80 we come to Meridian, Mississippi. This postcard, with a postmark of 1909, shows Fifth Street looking east in Meridian.

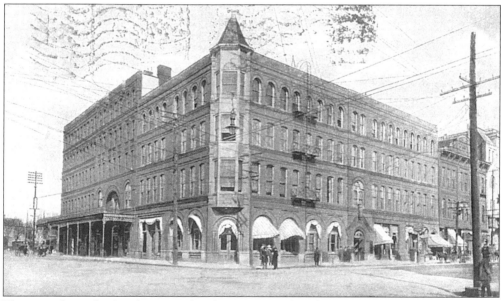

This view shows the Southern Hotel and First National Bank of Meridian during the same time period. The postcard was sent in 1917 to Mrs. I.D. Sterling in Jackson, Mississippi, from a relative. It explained that he had gotten over "the siege of measles" and lost 15 pounds.

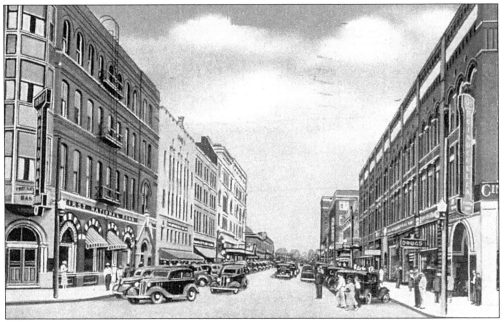

This view from the 1940s shows Fifth Street in Meridian and the First National Bank on the left, similar to the previous picture of the First National Bank. Fifth Street was the heart of the city's business district.

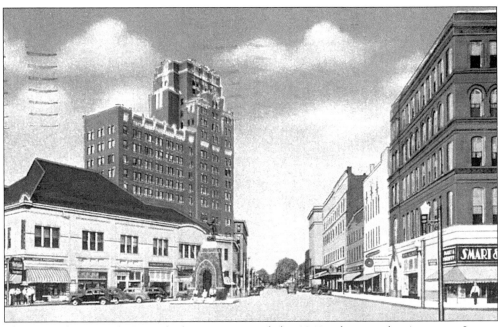

This view shows Sixth Street looking east around the 1940s, showing the American Legion World War Memorial and the city's largest office building in the background, the Threefoot Building on the left. Retail stores are on the right side.

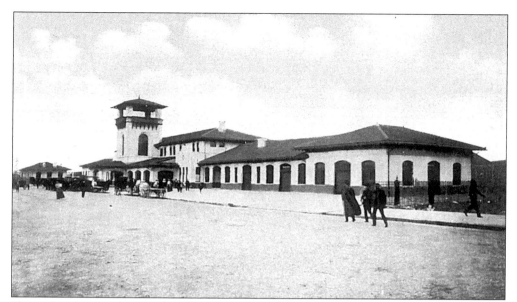

Shown here is an early view, from between 1907 and 1915, of the Union Station looking east in Meridian. As early as 1902, Meridian had two major north and south railroads running through the city, making it one of the largest cities until 1920.

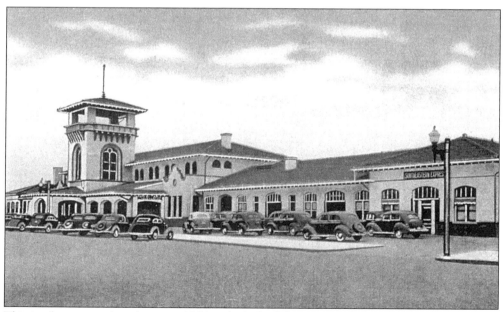

This is a later view, from between 1930 and 1945, of the Union Station in Meridian.

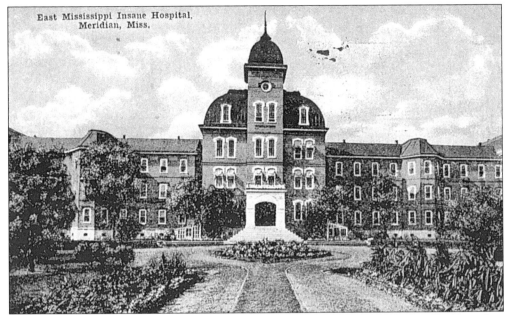

The East Mississippi Insane Hospital is shown here in a card postmarked 1922. It opened in Meridian in 1885 as the second Mississippi institution for the care and treatment of the insane. In 1911, there were 604 patients.

This postcard, postmarked 1936, is a side view of the East Mississippi Insane Hospital at Meridian. This is a view of the original structure, built on the Kirkbride Plan with an administration building in the middle and two wings on each side.

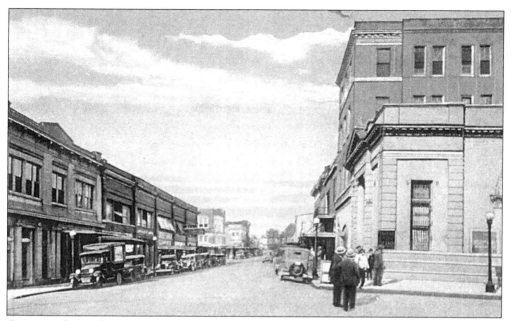

Going southwest from Meridian, we come to Laurel, Mississippi. This postcard from the 1920s shows Central Avenue in Laurel.

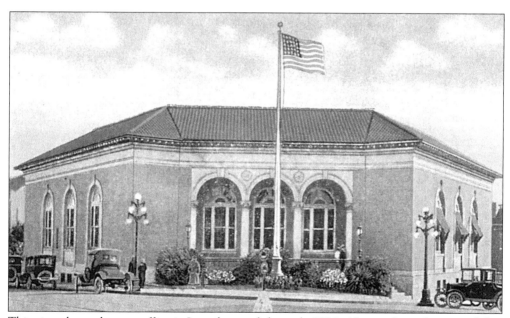

This view shows the post office in Laurel around the early 1920s. Notice the early automobiles.

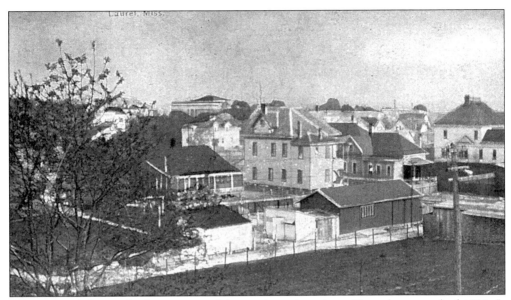

This postcard shows a birds-eye view of the residential section of Laurel, postmarked 1911. It was mailed from Laurel and sent to Miss Nan Crawford in Tylertown, Mississippi, which was about 80 miles southwest of Laurel.

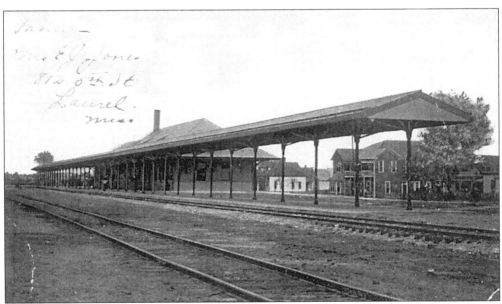

Shown here is the New Orleans & N.E. Railroad Depot of Laurel. This railroad through Laurel was a major source of transportation from New Orleans to Hattiesburg and Meridian, and it connected with others further north or east and west.

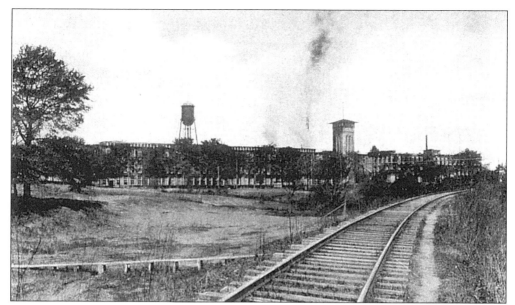

This is a view of the cotton mills in Laurel, Mississippi. Notice the railroad track that transported cotton to and from the mill.

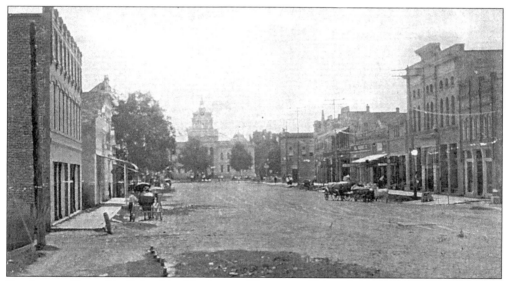

Southwest of Laurel is Columbia, Mississippi. This view of Main Street in Columbia was taken around 1907. Notice the dirt street, horses, and buggies. This town became the home of the J.J. White Lumber Company. The president of the company, Hugh L. White, became governor of Mississippi in 1936.

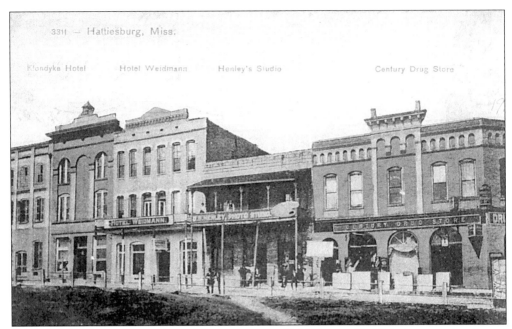

East of Columbia is Hattiesburg, Mississippi, on old Highway 49. This is an early view of Hattiesburg. On the left is the Klondyke Hotel, Hotel Weidmann, Henley's Studio, and Century Drug Store. D.B. Henley was a local photographer.

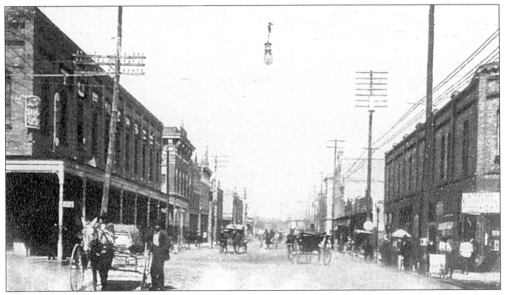

This c. 1907 view was taken on Main Street looking west to Front Street in Hattiesburg. Hattiesburg was a major lumber empire by 1912, having enough mills to produce more lumber that any other city in the world.

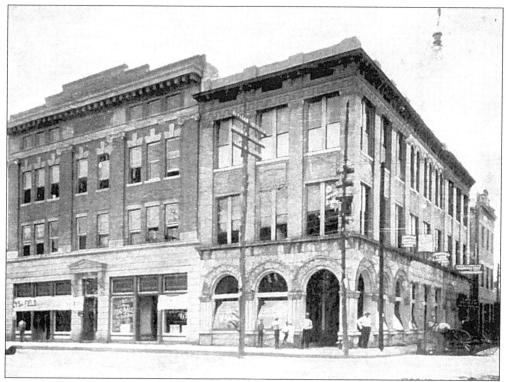

An early view copyrighted in 1906 includes the Kennedy Building and Citizens Corner of Main and Front Street in Hattiesburg. D.B. Henley, a local photographer, published this and the previous postcard.

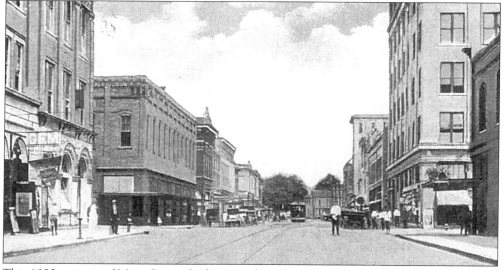

This 1920s view is of Main Street, looking north within Hattiesburg. The Gem Theater is on the left, displaying what was currently playing. Two more stores on the left were a millinery and drug store.

The Hattiesburg Fire Company No. 1 is pictured in this early-20th-century postcard.

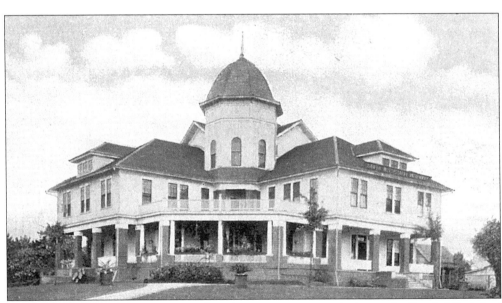
This early picture, of the same period as the previous postcard, shows the South Mississippi Infirmary in Hattiesburg. This hospital was opened in 1901 with a 30-bed capacity.

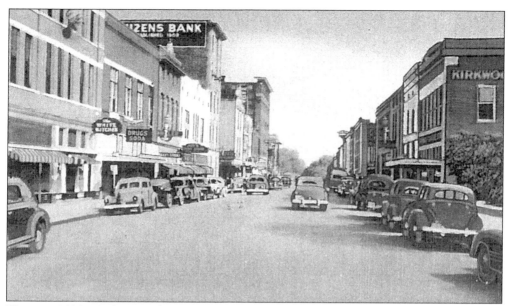

This is a 1930–1945 view of Main Street, looking south in Hattiesburg. The Citizen's Bank Building (left) can also be seen in the picture at the bottom of page 97. The buildings on the right look much different from those in the 1920s view.

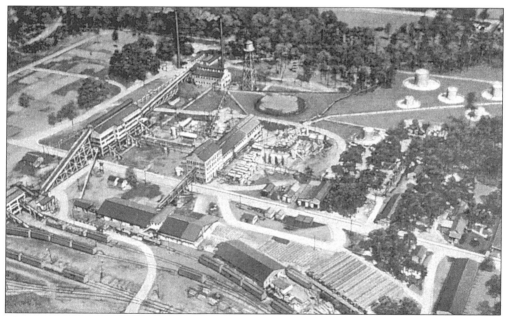

The Hercules Powder Company Plant, a new industry in this area, was a chemical plant located in Hattiesburg. It was in operation from 1930 to 1940.

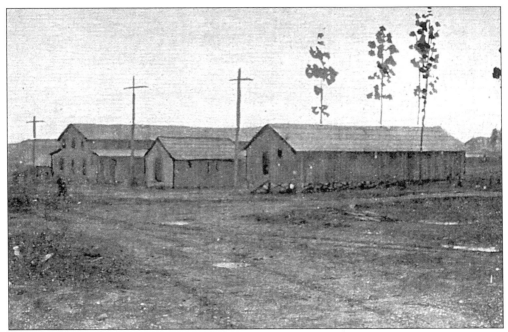
The following six postcards will show Camp Shelby, located south of Hattiesburg on old Highway 49. The first four of these cards will show pictures during World War I. Pictured here is the post office.

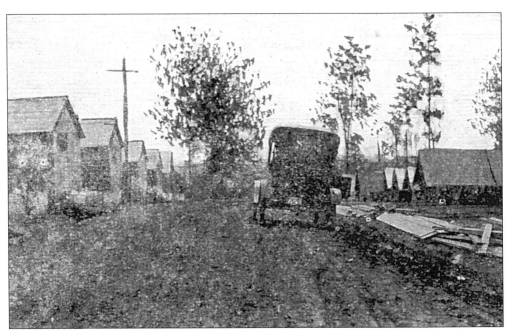
Depicted here is a street scene at Camp Shelby. Opened as Camp Crawford in 1917, it was renamed Camp Shelby by the Indiana and Kentucky National Guardsmen who trained there in WW I.

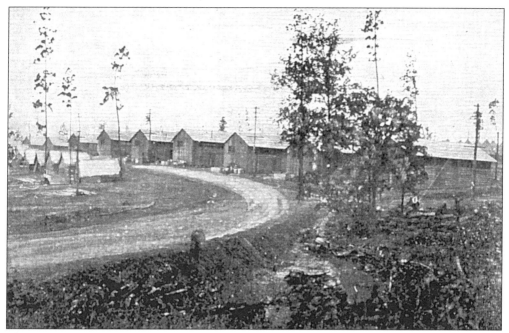
This postcard shows a general view of Camp Shelby during WW I. Camp Shelby was deactivated after WW I and reopened in 1934 strictly for National Guard use.

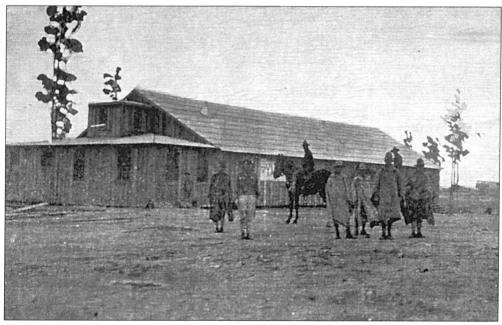
The YMCA building at Camp Shelby is pictured here as it appeared during WW I.

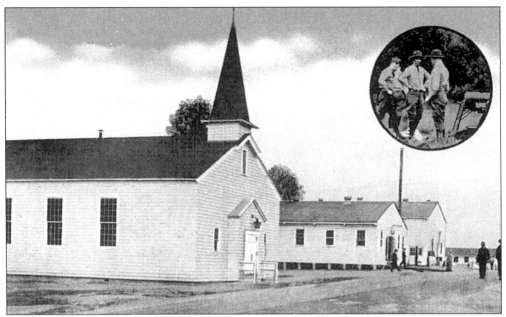

This postcard from the WW II era shows improved buildings with a chapel, post exchange, and recreation hall at Camp Shelby. Reactivated in 1940 for as many as 75,000 soldiers, the camp covered over 300,000 acres.

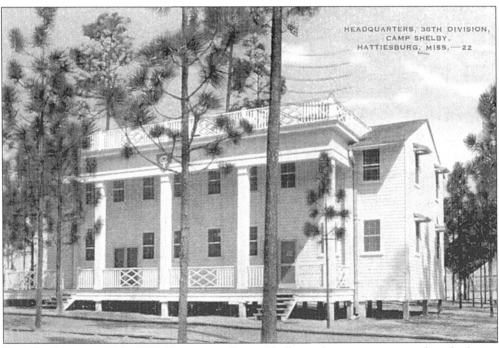

The Headquarters of the 38th Division at Camp Shelby is shown on a postcard made during WW II. A family postcard from Pvt. L. Burge, postmarked from Camp Shelby in 1942 to his sister, Mrs. Andy Powell in Lucedale, stated, "write Andy (her husband) real often for he looks for one every day."

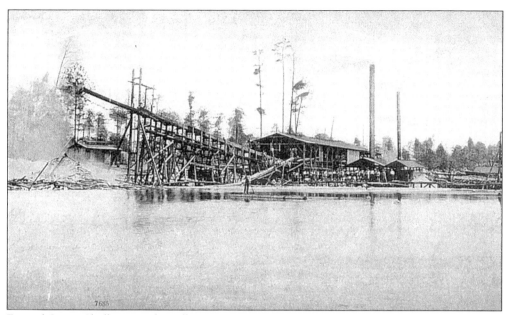
East of Camp Shelby is Leakesville, Mississippi. This postcard shows the Leakesville Lumber Company between 1907 and 1915.

This postcard shows a Leakesville dormitory and school building around 1910.

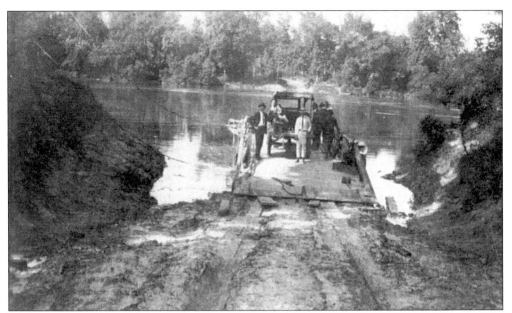

This Scott family picture was taken of the Wilkerson Ferry on old Highway 26, between Lucedale and Wiggins, Mississippi, all located south or southwest of Leakesville. It is possible that this picture was taken around 1940 because a better road and bridge were built after 1950.. Walter Scott and several sons appear in this view.

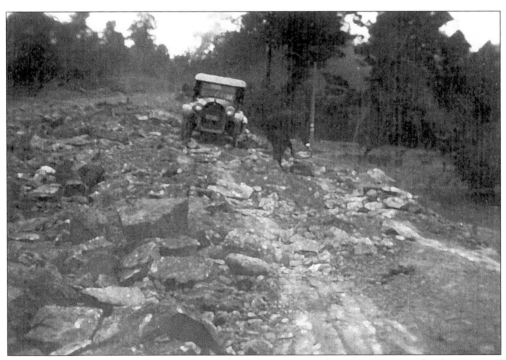

This Scott family picture, showing the road conditions around 1930, is suspected to be a view of old Highway 63 before it was completed. It is probable that this was the car of the Scott family, who lived in Lucedale.

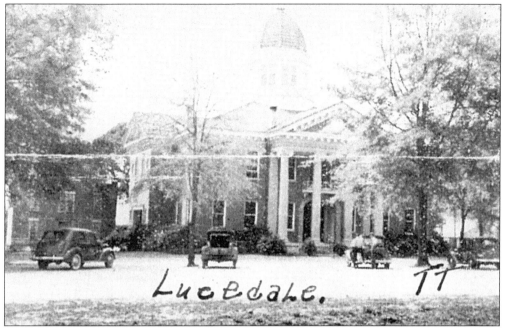

This is a postcard of the George County Courthouse in Lucedale, Mississippi, taken in the 1940s. Lucedale was created when the Mobile, Jackson, and Kansas City Railroad Company penetrated the land through Jackson County to Hattiesburg, spawning a number of villages along the way. In 1910, north Jackson County formed George County, making Lucedale the county seat.

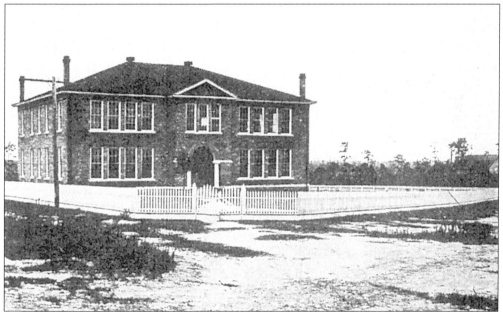

Lucedale High School is pictured c. 1911 in this view from the collection of Lucious and Clarabell Burge. They currently live in the old Burge family home purchased by J.W. Burge in 1923. Lucious is the brother of the author's mother, Alma Lee Burge Scott, who is deceased, and of Myrtie Burge Powell, who still lives in Lucedale.

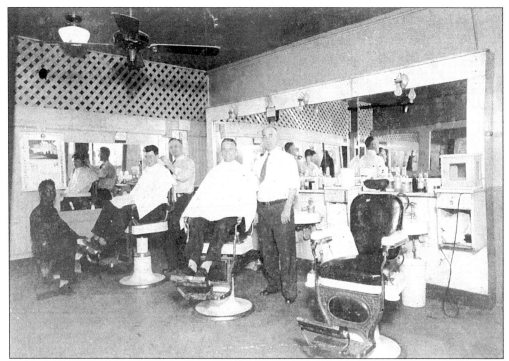

This is a photo taken around 1935 inside the Morgan Hotel in Lucedale, Mississippi. The barber on the far left is Andy Powell, who later married Myrtie Burge. He arrived in Lucedale by train and worked for Mrs. Morgan, owner of the Morgan Hotel, in the barber shop. The Morgan Hotel burned in the late 1900s.

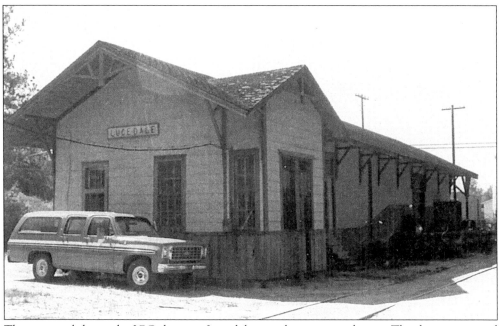

This postcard shows the ICG depot in Lucedale, in a later postcard view. The depot remained the same for many years and is now gone.

Silas S. Scott, the author's father, is pictured around 1915. This postcard was taken in Iowa, while the Scott family was visiting relatives. Scott retired from the Mississippi Highway Department as a civil engineer after seeing many changes in highway development. He died several years later in Clinton, Mississippi.

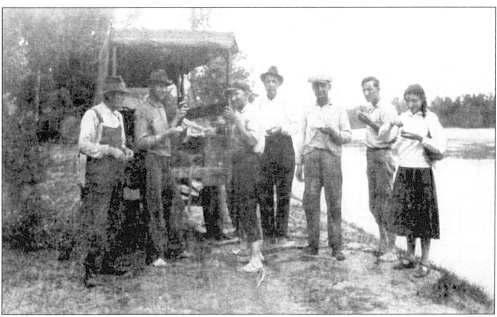

Six members of the Walter Scott family are pictured here. The author's father is third from the left, and the author's great-grandfather, Silas Steel, who was from Iowa, is fourth from the left. Notice the road conditions.

This family picture shows the first buildings that Walter Scott and his sons built after moving to Lucedale, Mississippi, in 1913. The woman in the door is Sylvia Scott, wife of Walter. These buildings became part of the farm as the home was built later. The Scotts originally purchased 323 undeveloped acres near Lucedale from the Lampton Realty Company, which was based in Chicago. The company sold 26,000 acres of land in George and Jackson Counties of Mississippi in the early 1900s.

This is the Walter Scott home which still exists but is no longer in the Scott family. Sylvia Scott lived in the house until the 1960s. It was sold out of the family in 1967 and is presently the Bill Wilkerson family home.

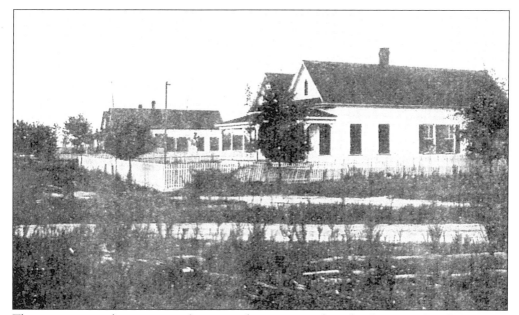

The pictures on this page are from an advertisement that the Lampton Land Company produced about developing towns south of Lucedale in the early 1900s. These towns are not on the 1950 map. This view shows the "neat homes of Argicola—a coming town." Argicola has continued to be a small community in George County, Mississippi.

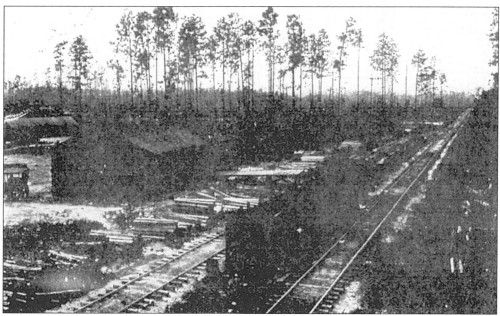

This picture shows the "townsite of Hurley—a town in embryo." Notice the site of lumber cutting and a railroad. Many communities in this area developed around railroad stations. Hurley is still a small town in Jackson County, Mississippi.

James L. Galloway is shown in this postcard view at Harleston, Mississippi, on February 25, 1911. He owned a sawmill in George County and his daughter, Mrs. Hazel Barr, currently lives in Lucedale. Harleston was a small town located south of Hurley, in Jackson County, in the early 1900s, but has not been identified as a town on later maps of Mississippi.

Pictured here is Foundry Street, near the office of the L.N. Dantzler Lumber Company at Moss Point, Mississippi, around 1905. The L.N. Dantzler Lumber Company was established in 1887 and became one of the wealthiest corporations in southern Mississippi. Mr. L.N. Dantzler had seven children, several of whom carried on with the family business until 1938, when the plant sawed its last log, shut down, and ended a century of large-scale lumber manufacturing. The Dantzler Pulp Mill, established earlier to utilize the by-products of the sawmill, became part of the International Paper Company and remains in operation today.

Six
THE COASTAL TOWNS ON HIGHWAY 90

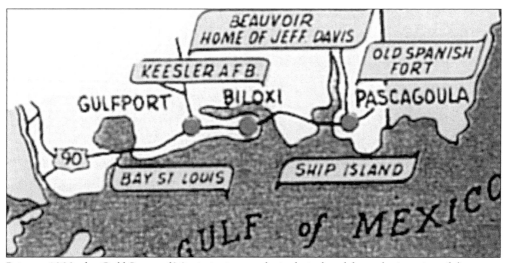

Prior to 1900, the Gulf Coast of Mississippi was relatively isolated from the interior of the state. Roads, if available, were poor due to the destruction of lumber hauls. Trains running between Mobile and New Orleans were constructed in the late 1800s as towns along the railroad line grew. By 1900, the Mobile, Jackson, and Kansas City Railway had snaked its way to Hattiesburg, spawning a number of towns, doubling the number of coastal counties and increasing the population of this area.

The outbreak of WW I sent shock waves through the area's economy. The export of both timber and seafood dropped, and the lumber mills were shut down. The lumber mills were reactivated in 1916, when the Allies placed huge orders for timber needed in trench support structures on the Western front. The population quadrupled as huge firms such as the International Shipbuilding Company set up to build military supply ships.

It was WW II, however, that gave this area a beehive of activity. An Army Air Corps training facility became Keesler Field in Biloxi. The International Shipbuilding Company was leased to industrialist Robert Ingalls to replace the slower, costlier construction of ships through welding. The Ingalls shipyard became the workhorse of the U.S. merchant fleet, producing the majority of ships during WW II. The war seemed to improve the economy as the coastal area continued to grow.

Biloxi became the third-largest city in Mississippi after 1950. Now we shall see what this area looked like in the early 1900s, starting on the east side of Mississippi and moving westerly to towns on the coast.

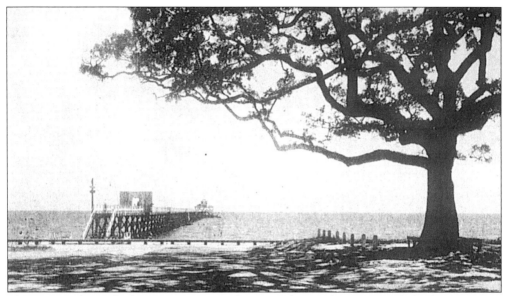
This postcard, made between 1915 and 1930, shows the municipal bathing pier in Pascagoula, Mississippi.

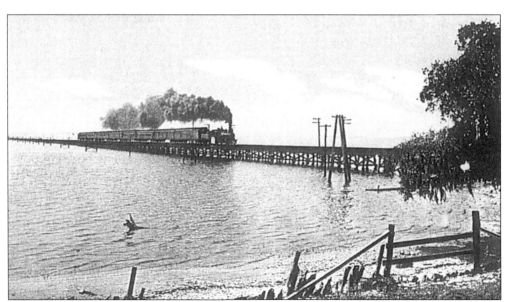
With a handwritten date of 1905, this postcard shows the L&N train crossing the back bay into Ocean Springs, a town between Pascagoula and Biloxi, Mississippi. This Louisville & Nashville train ran between New Orleans and Mobile, along Mississippi's coast.

This postcard is postmarked August 19, 1909, and bears the message, "Will beat B to Missouri Morn, WRG." Pictured here is Washington Avenue in Ocean Springs, Mississippi.

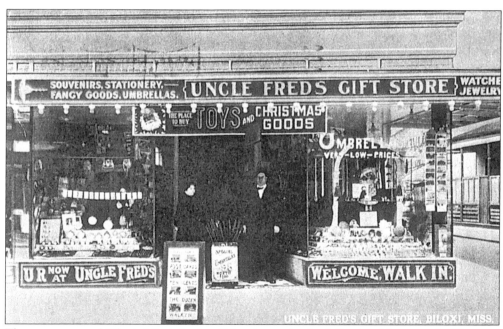

The next town of Biloxi, Mississippi, will be shown in the following 15 postcards. This one shows Uncle Fred's Gift Store, which carried souvenirs, umbrellas, and postcards. It was postmarked 1914 and had a typed message stating that local view postcards were 10¢ a dozen. It was signed by Uncle Fred.

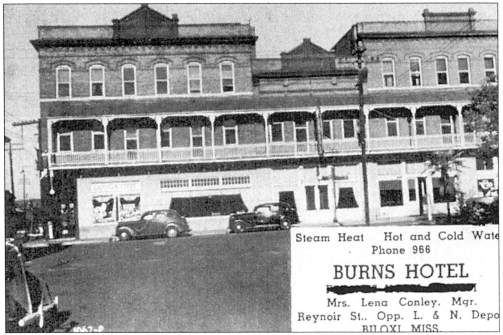

Advertised on this card is the Burns Hotel in Biloxi. The hotel had steam heat and hot and cold water. It was located on Reynoir Street, opposite the Louisville & Nashville Railroad Depot.

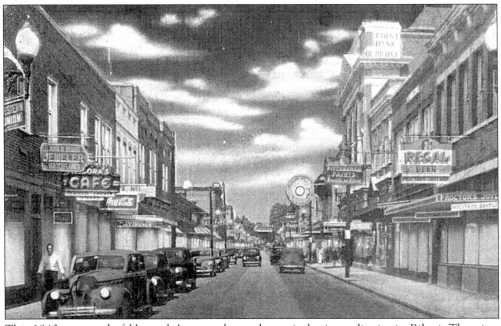

This 1940s postcard of Howard Avenue shows the main business district in Biloxi. The view includes the First Bank of Biloxi, a store with military supplies, a cafe, a jeweler, Western Union, and of course, a Coca-Cola sign.

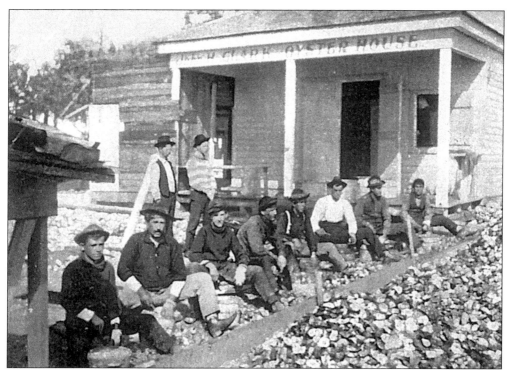

This postcard shows individuals shucking oysters at the John H. Clark Oyster House. This activity was typical of workers in the seafood industry around 1908.

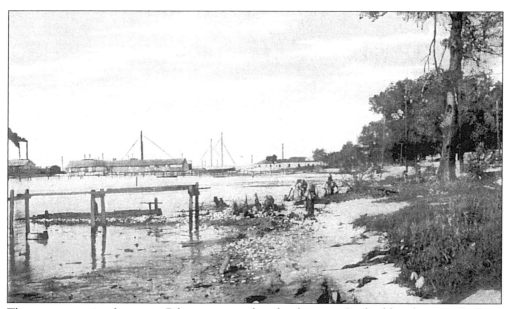

The oyster canning factory in Biloxi is pictured in the distance. Seafood has, historically, been an important product in this area, but transporting it to other areas was difficult until better railroads and roads were developed.

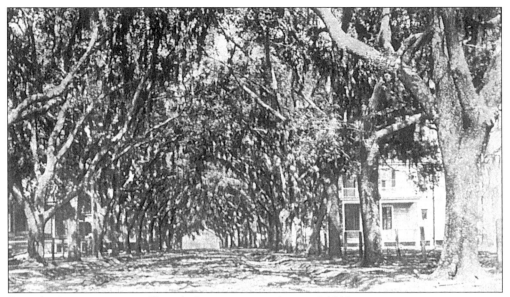
Benachi Avenue is pictured here before it was paved around 1908.

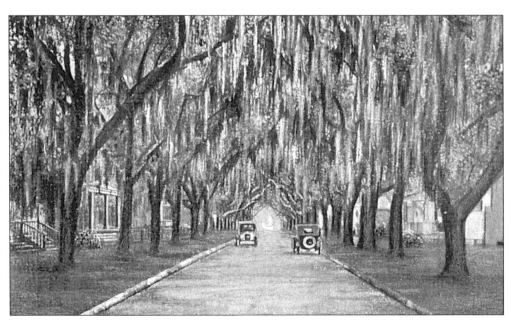
This view shows Benachi Avenue after it was paved around the 1930s. This avenue features one of Biloxi's most treasured views, with moss-draped oak trees forming an arch, leading to the Gulf of Mexico.

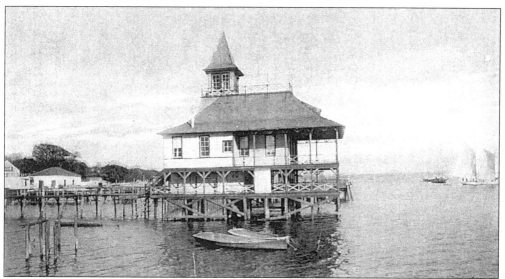

This postcard of the Biloxi Yacht Club was postmarked 1907 and addressed to Miss Maria H. Starling, Washington Avenue, Greenville, Mississippi.

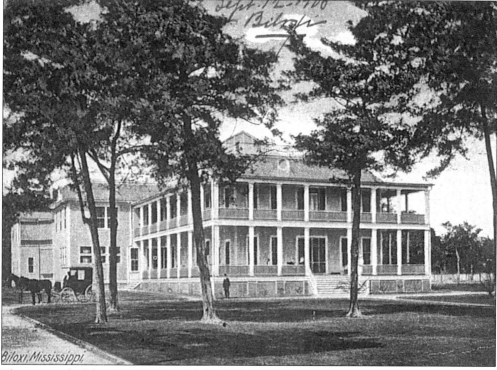

This postcard of the same time period shows the Biloxi Sanatorium, which was opened in 1902 with 35 beds. The postcard was sent from Miss Maria H. Starling to a relative, Mrs. Joe Linsey, 510 West Oak Street, Louisville, Kentucky. The message reads as follows: "Come down here and let us operate on you. I will nurse you. Cheer up there are better times." The Starling family has been associated with Greenville, Mississippi, in this book.

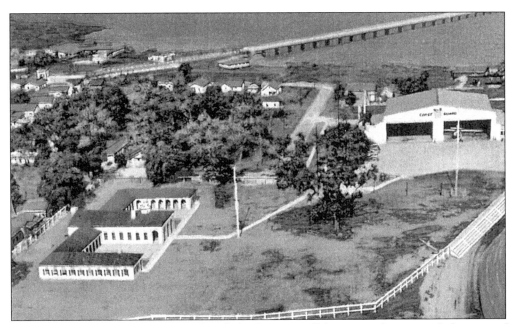

This aerial view of the U.S. Coast Guard Air Station in Biloxi was taken around the time of WW II. Shown is the hangar and apron at the upper right and a barracks building on the left. A fleet of powerful amphibians and seaplanes was maintained in this station.

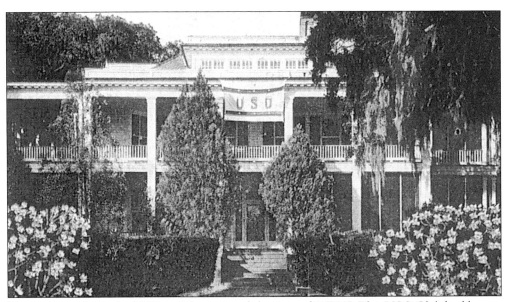

This postcard shows the USO in Biloxi around the time of WW II. This USO Club had been a traditional southern estate overlooking the Mississippi Coast. It was opened for women in the armed forces, female war workers, and female relatives of service men. The facilities included a dormitory, nursery, laundry, kitchen, and recreation area.

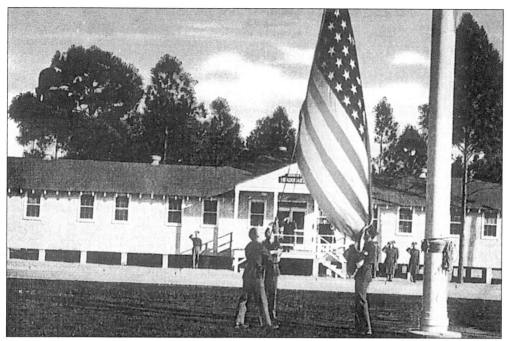

Depicted here is the lowering of the flag at Keesler Field in Biloxi. This was a traditional sunset ceremony held in front of the headquarters at the huge Air Corps Technical School at Keesler Field during WW II.

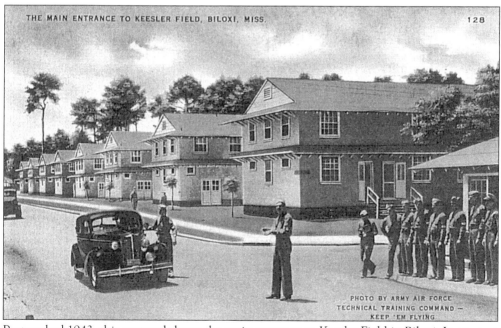

Postmarked 1943, this postcard shows the main entrance to Keesler Field in Biloxi. It was sent by Pvt. Joseph P. Morelli at Keesler Field to his parents. This Army Air Corps facility trained over 141,000 mechanics and 336,000 basic trainees.

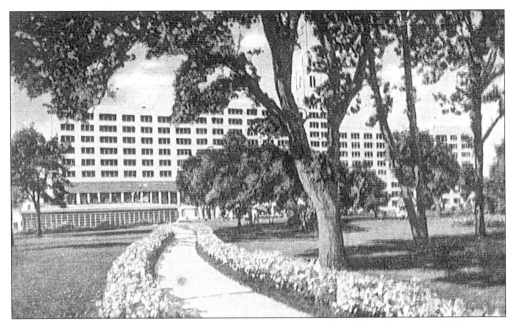

This 1930–1945 postcard shows the Edgewater Gulf Hotel, midway between Gulfport and Biloxi. It had a children's playground, glass-enclosed swimming pool, oak- and magnolia-shaded lawn, tennis courts, and 300 acres devoted to outdoor recreation with saddle horses, bridle paths, and a golf course.

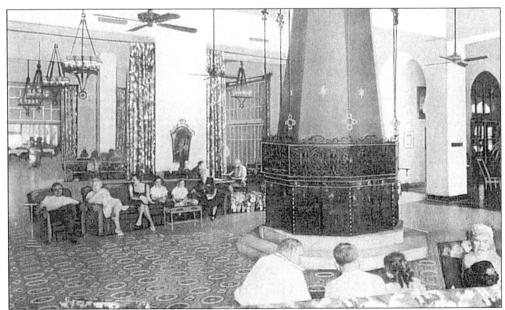

This postcard of the same period as the previous one shows the lobby and lounge of the Edgewater Gulf Hotel. Note the unique fireplace. The Edgewater Gulf Hotel was opened in 1924 and torn down in 1971 for the development of a mall.

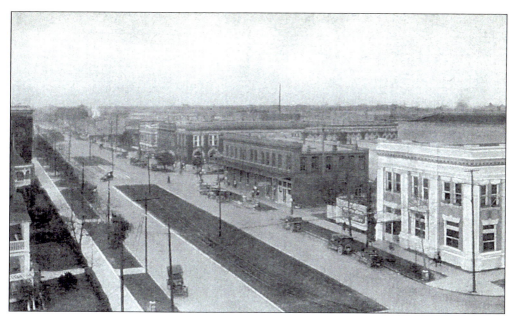

Continuing farther west on Old Highway 90 is Gulfport, Mississippi. The next 12 postcards will show views of that town. This is an early view (c. 1910) of Thirteenth Street, looking west in Gulfport.

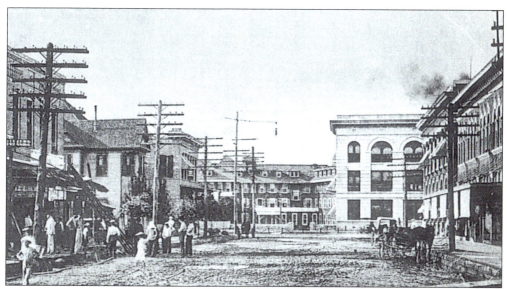

This postcard is also of Thirteenth Street in the same time period, but in a different location than the previous view. Note the unpaved street and absence of cars.

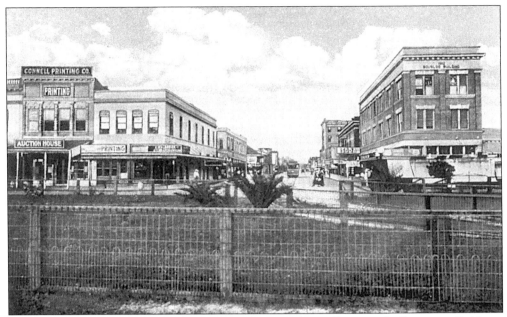

This postcard, published between 1915 and 1930, shows Fourteenth Street in Gulfport. Buildings on the left include Connell Printing Company, an auction house, and E. Waldheier & Atchmaker, Opticians. The building on the right has a sign reading "1912 Bouslog Building" on the front. The taller building at right is better seen in the view below.

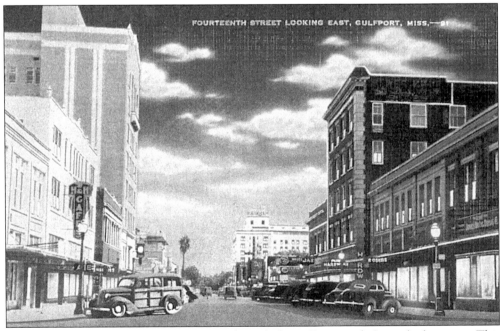

This postcard view, made between 1930 and 1945, shows Fourteenth Street looking east. This street was the downtown area of Gulfport. On the left is the H.&H. Cafe, and on the right is the Jones Bros. Drug Co. The Hotel Markham is the taller building in the background.

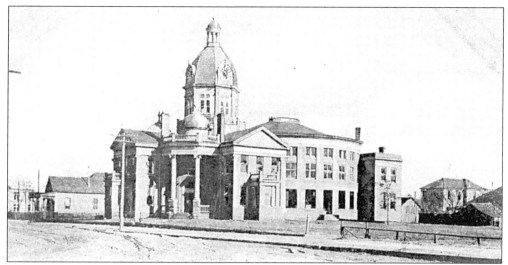

Copyrighted in 1907, this postcard shows the Harrison County Courthouse in Gulfport. The courthouse was opened in 1903, and was the first Harrison County Courthouse. The land was donated by Capt. Joseph T. Jones, who favored the Harrison County seat being in Gulfport rather than at Mississippi City, where it had originally been.

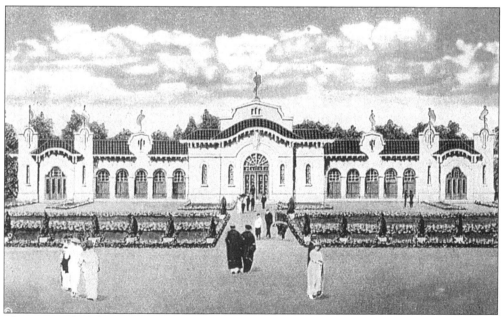

This postcard of the Mississippi Centennial Exposition in Gulfport shows the Manufacturers Building. The Exposition occurred from December 10, 1917 to June 10, 1918, to show off this part of Mississippi and increase tourism. These buildings were converted into the Gulfport Emergency Training Camp for training yeoman during WW I. After the war, the camp became a veterans' administration hospital.

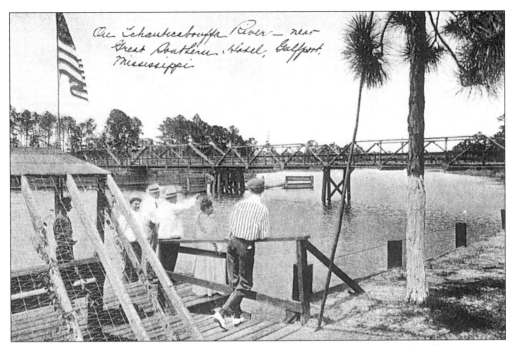

This c. 1905 postcard shows people standing on the deck of the Tchoutacabouffa River, near the Great Southern Hotel, at Gulfport.

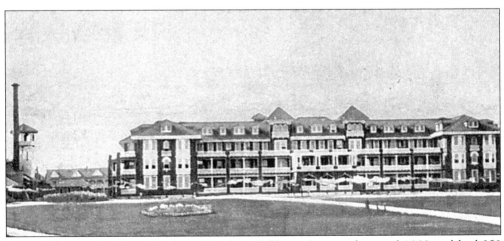

Pictured here is the Great Southern Hotel in Gulfport. It opened around 1902 and had 250 rooms with 125 baths.

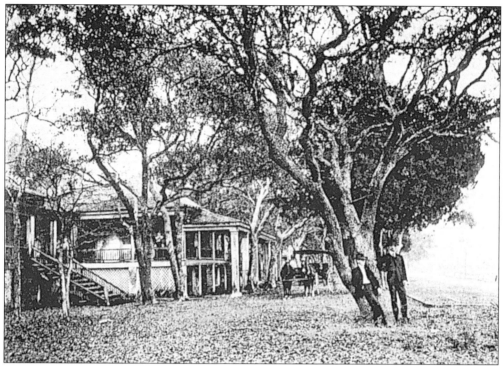
This postcard, postmarked 1905, features a "haunted house" near Gulfport. It shows the water, trees, and landscape around Gulfport.

This c. 1920s postcard, shows other vacation cottages in the area. These were called the Paradise Point Cottages and Restaurant, and were located on the east beach of Gulfport.

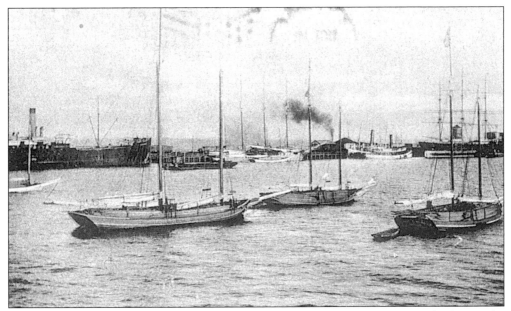

Postmarked 1908, this view shows the river, fishing boats at anchor, and steamers loading at the pier in Gulfport. A handwritten message on back reads as follows: "Came down here yesterday, will go back to Hattiesburg tonight. I am on Gulf of Mexico here, its a fine sight, my first of salt water."

This c. 1920s postcard shows the loading of ships on the pier at Gulfport. This is a family postcard, written to a sister of Sylvia Scott in Sutherland, Iowa. The writer was apparently visiting the Scott family in Mississippi.

Continuing along the Mississippi coast, going west, is the town of Long Beach. This postcard shows Jeff Davis Avenue in Long Beach, Mississippi. The postcard was made between 1915 and 1930. This quiet town was the home of the Gulf Coast Sanatorium, which faced the Gulf and had a capacity of 13 patients. It was a private facility for psychiatric cases.

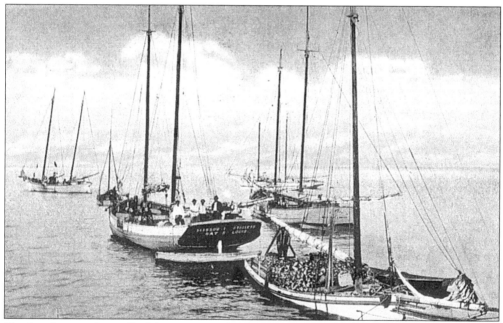

The last "postcard town" of the western side of Mississippi's coast is Bay St. Louis. Shown here is the oyster fleet at Bay St. Louis, Mississippi. A native of Bay St. Louis, Henry J. Tudury was a Mississippi's most decorated WW I soldier.

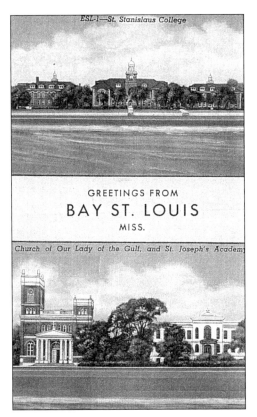

The city of Bay St. Louis has been noted for its fishing industries, which are located on the Gulf of Mexico. The city began as a railroad stop along the L&N Route. Two views published between 1930–1945 are shown here: St. Stanisiaus College and Church of Our Lady of the Gulf, with the St. Joseph's Academy at Bay St. Louis.

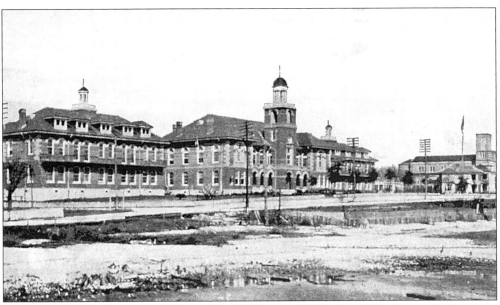

Pictured here is St. Stanisiaus College in Bay St. Louis, c. 1920s. Bay St. Louis was the first train stop from New Orleans to Mississippi. The area grew in the 1920s and became a major resort when a highway was built through the city, spawning a number of hotels, one of which was the Pine Hills Hotel.